for L)

HIDDEN IN PLAIN SIGHT

Moments of Beauty

by Ian Temple Roberts

*to the pride of Pennsylvania
in hiding over the moon*

Fonts used:

Palatino Linotype - Body font

Palatino - Table of contents

Optima - Header font, subheader font, title font

Produced by:

FriesenPress

Suite 300 – 852 Fort Street

Victoria, BC, Canada V8W 1H8

www.friesenpress.com

Distributed to the trade by The Ingram Book Company

A MEMOIR
IN ESSAYS AND
PHOTOGRAPHS

EYE—OPENING STORIES FROM LIVING
ESSAYS ON LOOKING—LISTENING
ALERTING OUR AWARENESS

CONTENTS

DEDICATION

To my parents Donald and Adelaide Roberts (Don and Ad) for nurturing my artistic angels and for showing me where to look and what to see in England's townscapes and country-sides … trees and towers, hills and waters, clear and cloudy, art and architecture, a nurturing setting … also for throwing me into Europe, first learning 's'il vous plaît' and 'danke schön' at home round our dining table.

To my traveling companions particularly the ladies, paragons of curiosity and intelligence, for always being out front in suggesting new places, trying different routes, meeting fresh faces, arranging inventive visits, looking again for more.

To my daughter Pippa for living with my life-changing shifts of interest and loyalties, for staying friendly and caring for me through thick and thin, not least for feeding me, just for being who she is.

To my brother Mark for walking the talk from our upbringing, caring for his family and mine, making me a friend.

PREAMBLE

The rush to action of today, the self-centered focus on a screen, the need for achievement in a hurry all drive my interests here: we miss much while much is there to be seen, hidden in plain sight.

At a basic level, the daily cries shrill through me. 'Where did I put my list?' (my book, my pills, the salt, that sharp knife, my recipe book) and other alarm calls of panic when a short look would see the 'lost' item in a trice. Poor attention, failing memory, gross disarray, even mild disorder all lead to 'lost' when all is to hand, waiting to be 'found'.

'My hat, my purse, my keys, my shoes', even 'my dog' lying out in a quiet spot where she was left a moment earlier. Laughable 'losses' but an ingredient in momentary madness and a shouting spree. Discomfort and loss of facts become the norm. Opportunities are not even attempted for lack of knowing the facts of them.

'Did you see she was feeling low?' Had you noticed, would you have treated her differently, more quietly?

Driving any road offers views large and small, of tree-trunks and arrays of leaves, clouds and flying birds, cars and people, the expected and the unexpected, including traffic. 'Did you see that stopped car (that icing ahead, the road works, my signal)?' We fail to notice critical items on the road ahead with unhappy consequences. 'May I ask, Sir (menacingly polite), were you driving while using that cell phone?'

I see people talking face to face less and less. Yet experts say 85% of human exchange is body language. Read Deborah Tannen. She has authored many respected studies of language and behavior. Talking needs much looking to see the way people are seeing-speaking. Seeing-speaking so that we also may catch more meanings and enjoyments on life's journeys with happy consequences. Catch the beauty and enjoy your life more.

And while you're looking, try listening too!

If this constitutes 'gripe', this is my gripe. Please can we all elevate the looking-seeing-talking-listening skills back into a chief position among the successful attributes and pleasures of the human race, attributes that put us ahead of early primates.

If our spacecraft Voyagers I and II decades into their journeys, now beyond the heliosphere can look-listen to worlds out there, we should be listening more closely down here, creature to creature, minute to minute.

I caution myself and you: my writings are not an attempt to set myself up as some miracle worker of images and essays. I am merely another photographer who likes his own work enough to share it with the universe, essays and commentary added.

Commentary tells of eye-opening events in my early and middle years that inform my present views. Essays include thoughts on the intangible qualities of sight and insight, beyond sight itself.

Like the flash of a bright idea, beauty moves past fast. We need to stay on alert to notice her presence … yet wearing glasses doesn't stop me seeing her.

Thus my brief obvious message: go crazy-happy looking and listening while you can. Find now the beauty in your life. Soak up what satisfies you. Not merely what pleases you, but all that deeply satisfies you.

Keep your eyes open for beauty that is deeper, wider, higher, further, more memorable, unlimited and moving than you ever imagined. Surprise yourself. Look into others' eyes. Daily.

Now share your beauty-views, your heaven-insights. Why not now?

EYE-OPENING INFLUENCES – STORIES FROM MY LIFE

Started only as a photo show, this book has developed another life. Beauty and Joy are central themes of my lookings-seeings. A moment of beauty with joy comes when you find what was 'lost'. Eyefuls of amazements.

Over now 80 years of knocking about this planet, many people and experiences have developed in me my levels of noticing/looking/seeing. I am disturbed to find I miss more than I used to. I need to ask others for details too often to be easy for them, for me. I stumble on, tap-tapping my metaphorical stick.

I look to remain safely upright, to see a stone before it becomes a stumbling block. I retain some brain, some hair, teeth, eyesight, muscle, hearing and energy at lower levels of past performance. I'm glad to have with me on my way helpful, friendly and younger folk beside me caring, challenging, imagining. My living-sticks.

My observations and comments are offered not as prescriptions. They are bits of my experience that have led me to this point and these conclusions. 'Consider and discuss' as the teacher says!

I bring to the table what I know and clearly recall of the people and places that influenced my 'looking-seeing'. Together they are a roll-call of seminal events in my life. Each opened my inner-outer eyes. I have some sense of possessing a 'third eye'. It 'sees-through' people and places. Helpful when I tune to it.

ESSAYS IN ENGLAND

Dad and Mum

Dad and Mum were both persistent observers of kids in classrooms (attention levels), and in the fields of scouting (pitching a tent straight; the kind-to-the-body safe way up a hill). They looked out for people in church meetings, spoke to the point gently, firmly, knowing the subject without being combative, gaining friends wherever they went. They voiced others' concerns, and discussed some with us. We gave to the C of E (Church of England) charity for poor and lost kids ('Waifs and Strays') and to Aunt Lucy's Leprosy Hospital in Vellore in India. They were care-givers all their lives. They hung good art on their walls (Cezanne, Vermeer). I'm circling back towards their ways.

I see now this was my opening to the 'and-and' vs 'either-or' dualism approach to life, the non-dualistic way we may all choose but counter-cultural to centuries of 'the/my way'. As a head-strong young man, I rebelled, raised my voice, went my own way, head-long into consequences.

They both looked for the contours of the land in Mum's geography studies (hand-drawn maps of the Kentish Downs), saw the beauties of views captured in Dad's b&w photographs (with his hand-drawn maps of their drives in 1920s

England), the characteristics of countrysides while looking for prehistoric stone circles, sketching dates simply cut into walls above doorways, knowing where to discover remarkable decorative arches in ancient churches (with the much-revered Pevsner reference books in hand).

They observed the lights and moods of an evening while sitting outside their home looking across the Mersey estuary to the Welsh mountains 40 miles distant (knowing mountains' names by map and compass, and the names of the shipping companies by funnel markings).

As my original models for intentional looking-seeing-talking-listening, they loved to discuss the finer points of everything seen and done. They lived a 'together life' of quiet joys.

They led me through wet, windy, sunny weathers, into eye-opening moments, more with Dad than Mum who liked her quieter letter-writing places (once, comfortable in a deck-chair letter-writing, seeing her ink bottle float away on the incoming tide at New Brighton). Dad wrote postscripts to Mum's many letters often adding neat sketch-maps to show how to find Mark and Rosemary's Fynnon Cottage or their overnight country B&B.

They took the ups and downs in their stride (WWII disruption, food and clothing rationing, refugee kids).

On small salaries we 'made do and mended' (socks and shirts, well, Mum did). Even with county and state scholarship money, it is still astonishing that they could send me then Mark to Cambridge. We never spent riotously but we did most of what we wanted and had thoroughly good times with long-lasting friends.

In Yorkshire we heard German bombers at night high above us on their way to make a mess of Liverpool's docks, Manchester's factories. Two London cousins stayed in our small two-and–a half bedroom 'semi-detached' as refugees from Hitler's attempts to wipe us out. We had two other refugees from the only part of Britain ever 'occupied': the Channel Islands, close to the French Cotentin peninsula which the Allies would retake in 1944. I kept scrap-books of newspapers' front-page maps (what else?) of the armies' progress after 'D-Day' until the fall of Berlin. Innocent in safety.

Strangely, I do not remember the final days: VE-Day (victory in Europe) celebrations in 1945, nor the '46 VJ-day (victory in Japan). Why, when I had followed events so closely? The awfulness of the two nuclear bombs?

Mum shouted at me when I didn't do as I was told. Dad never to my recollection ever raised his voice. He did lob, accurately, a blackboard duster onto the desk of an inattentive kid. Point made: that was Dad. Showing good-will and wit, if not remorse, the kids gave him one Christmas a new duster on the end of a long string for hauling it back quickly.

Both Mum and Dad live on inside me. I know how to shout. I throw things when frustrated. I also tend to go with what I've got. I keep 'stuff', books and clothes. I still enjoy pen on paper. I should beware un-noticed tidal surges!

With my boyhood Yorkshire friends next door, we developed our own aircraft recognition club. We made 'books' of our colored outlines of every plane, English, American and German. I knew anhedral from dihedral, Stukas from Messerschmidts, Spitfires from Typhoons, Sunderlands from Flying Fortresses. I still want to know what type of plane I'm flying. I always know where the wings are in relation to where my seat is and try to change it so I can see below.

We operated from the 'Anderson' air raid shelter in our back garden grass. We used cocoa tins and stretched string to communicate from below the curved corrugated aluminum roof set three feet into the ground. Primitive communicating but real! Little-disturbed wartime survivors but real. We slept indoors under the heavy wooden breakfast table. We were rarely disturbed but my awareness was developing!

We slid down scree in Langdale, bust our boots on Bowfell's stones, clambered up one or both Scafell's Pikes, 3210 feet. We found rocky chasms open before us, hiking by map and compass in thick cloud on top of Coniston Old Man 2635 ft stepping out of harm's way (just in time it now seems). We teetered the knife edge as we neared Helvellyn 3118 ft, all in the Lake District.

Mercifully Dick Hudson's pub emerged from the chilly mists on Yorkshire's Ilkley Moor, a modestly mighty 1321 ft to a shivering 8 year old, fully ready for the

joys of a roaring fire in the pub's inner room, the 'snug'. I can still sing all seven verses of dialect 'On Ilkla' Moor Baht 'at' (On Ilkley Moor Without a Hat).

Ten years later, I respectfully peered over the vertical drop from the top of Cir Mhor 2618 ft on the Isle of Arran in the Firth of Clyde near Glasgow, stomping up in hob-nailed boots ('beetle-crushers') before Vibram and NikeAir.

To keep some perspective, school friends became professional rock-climbers, writing the rule book, pioneering ascents from Wales onwards. Another adventurously flew onto the sands of Barra on the Outer Hebrides, later scaling South Africa's Drakensberg peaks, and leading conservation work on New York's eighteenth century water supply pipelines, then similarly in Alaska.

One of my rowing friends in college (he or I were stroke or 2 in our eight over several seasons) served in a prime Scottish Regiment in Malaysia dealing with the 'emergencies' there. I lived a largely untroubled life (no-one ever beat me up) not bombed even once, while my London cousins were bombed twice and survived. I saw the world through easy lenses (but for the rigors of Latin and Mathematics).

I learned to keep here and now in mind as well as the overall plan of the hiking group while walking with a very slow kid making heavy weather of a hike, both of us finishing hours after the others. This was my early experience of 'going with people from where they're at', a phrase which became my mantra for helping people as a team-work coach. Scout camps were where I started to learn about listening-looking.

At the end of my school career I was made 'Head of School' that led me over that year to produce two thick day-by-day journals of what worked, thinking they might help the next year's 'Head Boy' (I don't recall any feedback on their utility). My fellow assistant seniors, the 'Monitors', and I were the vehicles through which the staff ensured that 'school rules' were kept and minor misdemeanors were penalized. Since its founding in 1620 by a local man making his money as a 'merchant tailor' in London, it was always a boys-only place, about 300 of us in my 1940 years. Ten years after leaving school, monitoring turned into managing.

Our sister Girls' school since the late 1800s worked separately out of the original 1620 premises two miles away. Shared classes arrived in the later 1900s. Not in my

time were there mixed classes. Girls remained a remote tantalizing force of nature until long after late teen mixed friendships. The annual dance had my parents send me to the Fifty Shilling Taylors for a tuxedo, a 'DJ' with neat lapelled vest in heavy serge with button flies (this is 1952). I still wear it, genes having been kind to my waist line. My girl-friend wore Lilies of the Valley scent, muğuet des bois. She wasn't a 'date' but yes I thought, desirable ground for exploration.

Flying

I stayed long enough to be promoted to Warrant Officer in the Royal Air Force section of the school's cadet force. I failed the National Service eyesight tests, having worn 'glasses' from 4 years old. The friendly recruiting sergeant gruffly commented "You'll be no d—n good to His Majesty if your 'specs' (glasses) fall off". By-passing two-year army service I feared only being assigned to the Catering Corps and peeling potatoes (spuds); flying was really my 'thing', I gained one extra year at school and one at college. Suez crises twice stopped me taking RAF trips to Singapore, after having been kitted up and inoculated at RAF station Hawarden in north Wales (near my First Class Scouting hikes). Missed perfect eye-openings into Asia.

I learned to glide at Formby airfield (a real field it seemed to me, rabbits running, larks singing), winched aloft at the end of a wire tether until I pulled the toggle to be in control, floating for a circuit until I bumped down on the skid, always safely. Dad had damaged his back in a gliding accident, and taught 'math', a wartime skill and a 'reserved' occupation so he was never 'in action'. I vaguely knew he and we were lucky: only one Canadian cousin fought in WWII (turned up at home in his glengarry cap); one other, a CO 'conscientious objector' served his 2 years 'down the mines' in South Wales.

Brother Mark later served as a Royal Engineer officer in Egypt (knowing the sweet-water canal for being the opposite of sweet), being moved to Cyprus before the 'Suez' Crisis. None of us had to fire a gun in anger. Our sergeant demonstrated

the screaming 'wheee' of a penny shot into the air from a blank cartridge, the rifle on its butt on the ground (meant to impress on us the danger of blanks: it did). I never graduated to higher flying skills, but high enough to hook me into 'looking down' whenever I ride a plane.

Summer camps took us to RAF airfields in Wiltshire where I flew in two now defunct aircraft: in a Wellington and an Avro (A V ROE Company) Anson, a two-engine classroom plane with plastic windows (we cut off clouds' edges with our wingtips). We flew at low level in a DC3 (Douglas Dakota) with seats only along the sides and a wide open doorway for easy jumping out (the sergeant casually flicking his cigarette ash out of the unprotected opening). Eye-opening indeed and glad we were not parachuting.

Another DC3 flew me 30 years later into Kenya's Masai Mara, bumping over the Rift Valley's thermals while the pilot read the day's newspaper account of Musaveni's election as President of Uganda. I could see him through the open door into the cockpit. More open eyes.

Most dramatically I flew in the Wellington, a twin engine 'light' bomber, designed by Barnes Wallis on geodetic principles for lightness and strength. He had developed the 'bouncing bomb' skittering across the water to shatter the Mohne Dam and put the 'Dam Buster' Squadron into the public eye. We did a night flight over the Welsh mountains, cut short by a lightning-filled thunderstorm (thereby safeguarding our fragile teenage bodies, or our parents' fragile hearts).

I was (against regulations again) in the Wellington's bomb-aimer's prone nose position as we landed, but 'really good fun' whatever parents came to say about it (I assumed they knew and approved). Life's rules then were more casual, while parents loved us just as much. Apart from 'the war', there were fewer dangers for them to worry about. I recall every minute (so it seems) including the lightning flashes below me. Eyes open bomber boy. I didn't want to leave school. A caring teacher helped with a new mantra: 'Every end is a new beginning'.

Perfections

I went hiking and hitching rides in Scotland on my own the summer I left school. I cut a corner over the brow of a small mountainside above 'Royal Deeside' to save a long schlep on a hard hot road. It was a perfect summer day. I liked the look of the heather. I could read a map. Tomintoul was straight ahead beyond my short cut. Half-way, not on any trail, I stopped.

I heard silence. I was hearing the silence. It was all around. It filled me. The scents of heathers, the blue of empty sky, the warmth of sun, all remain with me today and forever. My happiness. My aloneness. My heaven. Perfection.

I knew I was close to the highest village in the Cairngorm mountains. I didn't know that my next ride would last a week. An English couple, not many years older than I, in a Land Rover, going to the far northwest. Perfect. They let me stay in their tent. More perfect. They had a caravan parked beyond Ullapool on the shingle of Ardmair Bay looking west over the sea to the Summer Isles. Multiplied perfections.

Summers on the far northwest coast of Scotland soak you in long sun-filled evenings. Even great storms of wind and rain blowing me out of my tent failed to drown my joys there. David and Gaye pulled me to safety inside their house on wheels a few feet away. On leaving I learnt they were on honeymoon! Generous folk.

In Europe

From their own holidays in France, knowing the benefits of discovering life outside one's comfort zone by 'going abroad', Mum and Dad sent me off into 1949 post war Europe. I was sent by way of a London Aunt, Mum's sister. She was another 'born teacher' who also painted flowers and knew all their Latin names. She told me to gather mushrooms for breakfast on the hilly Sussex Downs behind her house (I see them now in the sheep-nibbled short grass, and on our breakfast plates).

I went to ski in Austria with my school army cadet group, traveling by British Army of the Rhine (BAOR) train the length of the Rhine from the Hook of Holland (long before air turned cheap). I saw from close below the Cologne Cathedral spire still scarred by WWII fighting. I traded ciggies (very much against our rules) for Hoehner mouth organs through the train windows in the dark of night with blacked out people standing on the tracks when the train halted in the middle of nowhere.

I wondered at the networks of overhead electric lines (I only knew England's 'third rail' electric line) and stubby smoky black old steam locomotives. Until we reached the dawn purple glow on the Bavarian mountains, it all seemed black, blacker than bomb-ravaged Liverpool suburbs.

From still-rationed England, I gaped at the Easter spread put out for us on trestle tables in the snow and the sun, ham shaped like roses, seemingly endless food from the officers' mess. I learned to address the eighty year old lady in Klagenfurt correctly as 'gnädige Frau', honorable lady. I fell in love with the mountains beyond the Wörthersee over towards mysterious Slovenia, communist Yugoslavia. I sketched the slim church spires, the mini-onion domes, the view across the lake.

We were lifted to snowy skiing heights in what I remember as wooden boxes, not that oranges were in good supply, but just like orange boxes. Safety bars? What are they? I 'laughed my socks off' after getting my skis in opposing directions around a flattened tree stump. It hurt.

'Outvarts leanink', the Austrian instructor's earnest plea, still rings in my ears. We lost only one boy with a bent-back knee. Having loved the one experience that I carry brightly in my head today, I have never since skied. Multiple eye-openings.

The following summer my 3 years younger brother was (rashly I later thought) entrusted to my care hitch-hiking into France. Two-some rides were not frequent arrivals on the roads outside rural French towns. Our last ride back to Dieppe we separated. Brother reached home before me! But I rode to the ferry home in my favorite car: a low slung black, now vintage, Citroen.

We stayed 'en famille' to learn real French, living in the heart of Chartres. I saw the depths of 12th century blues in the cathedral windows but failed to see the

famous medieval labrynth. We youth-hostelled the Loire valley in simple places and in the spacious spartan chateau at Tours. I discovered the joy of Vouvray wine on the island off Amboise. I bought art that I still own while looking at Notre Dame across the Seine. I argued with brother Mark as to which of us would sketch the Pont Alexandre III (dualism running rife). He lost.

I have my pencil sketches in the handwritten report (in execrable French) that won me a school 'original work' prize. Mark and I are today close friends, he leading country church tours, as I would were I now in England.

In the Louvre I fell in love with the 'Winged Victory of Samothrace' perched, still there today, at the last grasp of the balustrade down the side of the stairs. I pencil sketched her too. I had consumed at home, at school, with urgency, 'The History of Art' by EVGombrich, 'The Meaning of Beauty' by Eric Newton. I pursued stories and pictures of the Gothic churches and early Saxon remains that surrounded me and cried out to be seen. One friend arranged his life to visit all of England's cathedrals. Stonehenge and Avebury's stones and stories have 'turned me on' as long as I can remember. Andean Tiahuanaco and Atacama too.

The Renaissance and especially the loveliness of Sandro Boticelli's women, the rigors of desert digging in Ur of the Chaldees, the mysteries of when and how people developed the lives we see today engaged my mind at all hours. The unanswerable aspects of ways ancient lives bumped into modern lives still intrigue me most. It is much the same with the hows and whys of the 'Big Bang' and the astonishing discoveries today about our origins coming from the 'Large Hadron Collider' set deep below Swiss and French mountains. Strange bedfellows, from deep underground to deep backgrounds of space.

In London, Cambridge and more Europe

Finally it was 'abroad' to London's 1951 Festival of Britain with modern architecture and design on the Thames South Bank in the form of the Skylon and the Royal Festival Hall. They 'blew my mind' may be anachronistic, but not far from

the truth. All this 'eye-opening' sparked my life-long pleasure in 'travel', in art and architecture, with archeology having sunk in at the stone circle in Cumbria's hills called 'Long Meg and her Daughters'. I knew I liked sitting at cafes eating and drinking. I later also discovered French oysters and mussels. London captured me, another special place beside Europe.

Sitting entrance examinations in the strictly classical Cambridge Senate House, I spent time looking up at the extraordinary medieval confections of King's College Chapel, filigrees and finials, flying buttresses, heraldic Tudor promotion. It was 'mind-blowing' but not before I 'got in' to enter Emmanuel College ('Emma' forever).

Walking into Emma Front Court to look at the façade of Wren's chapel and the Long Gallery windows above the arches gave further impetus to my love of special places. Deepening my awareness of beauty in buildings I dined (later) in that Gallery. The college silver shone on our tables. I was surrounded by strong 'looking-talking' friends. I discovered more about food and wine, Tournedos Rossini and Profiteroles au Chocolat, passing the port, speechifying.

Lighting the college chapel Wren-lovely stone of the east wall and up-lighting the Oriental Plane tree for our May Ball opened my eyes to dramatic effects and a small career in theater, creating school play sets, acting, and finding new life in unfamiliar places. Beer was discovered as an adjunct to becoming a member of the 'First May' crew (rowing eight). After working heart and limbs to exhaustion all week, sufficient beer went down our throats to replace what we had 'lost'. I can live a life this way? Upper body strength keeps me half-way fit today.

Intermittently we won and lost races. At Henley we lodged elegantly in an Emma man's house on Remenham Hill. Watched the big Russkies arrive with square red blades and do a lot of winning. Skinny-dipped in the river at midnight after being eliminated. Happy times but unhappy to be losers.

My second summer at Emma I spent six weeks in Germany using my still functioning language skills. I worked for the Youth Travel Bureau (in a corner in the underground arcade near Harrods). I spent every week taking young people to different famous places. We had a happy family hotel in Oberwesel-am-Rhein,

upstream from the Lorelei Fels (Rock - proud of my German). Goethe in outdoor theater looking down into the Rhein. Cruising in the long thin steamers on the fast moving stream as far as Boppard then to Trier on the Mosel. Up to Mainz past more vineyards it seems, than sheep in Yorkshire. YTB ran two-center holidays. With only four arriving one week, I left them many visiting ideas with the hotel staff.

With the larger group I went into the Black Forest. As group leader for YTB, 'gruppen-führer', I went to check the way things worked there in Todtmoos (gloriously well!) I organized a trip into Switzerland, the Rhine Falls, Lake Lucerne, the Bodensee. My poor instructions meant waiting in the wrong place for half the group on the way back.

The sun shone all the time. I loved the train travel. For me it gave talking time, down to earth time, for seeing where things are, a friendly space in unknown countries. It still does. Public yet private. Engage and retreat time. The opposite of stress.

The next year I volunteered myself again to YTB. I enjoyed the 19 to 29 year old travelers. Again by train across Germany overnight into northern Italy by the Brenner Pass, mountains on mountains, marvels on marvels (before air had made a dent in the popular vacation business). With only my Spanish as a (useless) guide to surviving in Italy, I had seven of the best weeks of my life between Verona (3 nights) and Venice (4 nights) then sending each group on to sun and sand on the Adriatic. Again, perfections.

La Scala was in residence in Verona making opera fans ecstatic at night in the vast Roman Arena. Families and ancient paterfamilias brought baskets of food and wine to share during each 45 minute intermission. Romeo and Juliet disappeared over the topmost rim of this perfectly functioning ruin as they 'ran away'. The city's streets rang every day, all day long, with glorious voices lofting well-pitched notes through open windows in practice for the night's show. Was it Tito Gobbi and Renata Tebaldi? Aida, R&J, Otello. Seven weeks. Each week new experiences repeating our operas. Glyndebourne is superior, tops. Verona is over the top, pop.

Verona's street trees were heavy-scented. One day in a small group of four, we sailed serenely, slowly, feet in the cool lake waters, on the Lago di Garda. We spat red melon pits into the hurrying Arno, feet hanging from our perch, the Roman 'Greek' theater on the other bank. A lovely city to see again, with or without Juliet. Can it get any better?

Yes, by arriving in Venice, at the train station, a vaporetto ride the length of the Grand Canal, marveling as we passed St Mark's square was the answer, the next eye-opening perfection. Seven weeks of return visits to the family trattoria in a triangle of a square off the Riva Schiavoni were bliss. Again as leader I was asked to get each group, always between 4 and 10 strong, to all the best low-cost high-reward places. My choices were discussed and that's where we went.

They wanted and devoured acres of Titian and Tintoretto flesh, miles of Canaletto canal-side, mountains of Doge's Palace and San Marco decoration, fortissimos of fireworks from barges and gondolas. Mountains of magical music, pinnacles of juicy pastas, amazing memories ...

Looking-Seeing-Tasting! I own a Canaletto print from shortly after these times. Perfections.

'New life in new places' turns into a mantra for most of my life's patterns. Cambridge degrees were awarded in two parts. I 'ran out of steam' after a good Part I History degree (a 2:1) and a miserable Part II pass in Theology. I was warned off teaching by sensible parents. But it was the only life I knew. It was the only job I went for.

The Working Life

Looking to make a small fortune early was my aim, although I didn't know how. Travel with art and architecture and archeology were my passions, with a classical music background. I knew I enjoyed being with people. 'People Watching' was a book gift that touched my interests. It took several years and mis-directions to find that opening. I never tried 'Fine Arts' as a career. I remained happily amateur.

Earning 'good' money with my fancy Cambridge degree I imagined was what I 'should' be doing. Yet I found that the corporate world spoke of 'marketing' and such, which I didn't much enjoy or properly understand. Fixing on one 'sight' without a larger vision from friendly others, carries many mis-direction dangers. But I did choose, through talking with London teacher friends of Dad's, that being a 'generalist', not a specialist, was to be my line. And so it proved to be.

I taught school, 11 to 18 year olds, in the northwest of England. I designed stage sets for school plays. A strong minded director hauled me onto the stage at the Amateur Opera and Dramatic Society-owned stone-built Georgian theater. Their leading lady played a perfect Alice to my Mad Hatter (type-cast, I now see). But I could not manage younger kids in large groups. Nor the rules of rugby football. And I couldn't get excited about small senior groups prepping for college entrance. It was all too closed in. I 'ran out of steam' again.

I lived three months at home answering job advertisements, while being an all-purpose teacher to the lowest grade class at eleven-year-old level in a school near Everton soccer club. Here I came face to face with those who rarely made good grades, had a suspicion of anyone speaking what was then known as BBC English. One of these boys would run fast across the playground as school ended to a sub-stantial 'scouse' Mam waiting at the gates to be sure no-one beat up her diminu-tive Johnny ('scouse' is a Liverpool Irish stew and nickname for the locals). Coal for winter heating was kept inside their bath-tubs. Some kids I heard were even stitched inside brown paper for winter warmth. Taking them to compulsory swim-ming in the public baths (pronounced 'bats', as if the nasal passages had closed, a distinct possibility with Liverpool weather), was a noise-some raw experience.

Although I felt awkward in public places with some groups, it had not occurred to me that we lived such a rarified existence: true, our connections were all aca-demic. Our lives were quiet, radio only, low-cost public transport, school, church and scout centered. Organized politeness and respect was all. Even so, as disobedi-ent kid and adult, I failed the rule book frequently, only to return to the 'rules' later in life. I was soon to launch myself into even more unfamiliar spaces. Better keep my eyes open, I said, although they were then barely slit-open.

I allow myself to experience uncomfortable times. I stay the course, but only for so long. Then I move. I never found ways to talk fully through alternatives with dispassionate friends and almost never with my parents. Talking through anything close and personal has always been a difficulty only overcome in my last 15 years. I come-and-go, a see-saw life. I couldn't talk but I could look. I can and do. Pretty women and out-of the-way places. Out of windows. Planes and trains.

However, each experience has opened me to every next experience. I do what I can to make the best of what is happening. 'Keeping eyes open'. Please let kids gaze out.

In Commerce

I was hired by a large manufacturing company headquartered near Shrewsbury to be liaison officer between factory floor and sales. This made a huge departure for me from the quiet teacherly life all my family had led. I became familiar with hulking pieces of machinery and pals with their hulking operators cutting dangerously heavy slabs of metal (thud thud onto the floor) into car and truck doors, roofs and body parts. I liked the newness of the post-war vending industry. Orders for the big vending machines we sold passed through my hands and out into everywhere in Britain from Scotland to Essex. I liked my boss, an energetic Australian whom I later met again as a headhunter in London. I liked our small sales teams. I was opening myself.

Tracking myself into new lives, again. I ended up on the border with Wales, on Shropshire's Wenlock Edge, sharing a vast old manor house with the much older personnel director, divorced (another novelty for me), willing to share with a newbie. He existed at weekends on a large bottle of whisky, the TV, the horse betting lists in the paper, and his bookie. The phone lived on a table by one of two sofas in front of the fireplace, the lifeline to happily-hoping winning weekends. His lady friend stayed over. He cooked dinner. She casually sat upon one sofa, unscrewed her left arm and deposited it beside her. Whoa! Novelty twice over!

15

London friends arrived in low-slung sports cars that disappeared below hedge-rows on winding country roads.

All first experiences for me, but not before my year in a room in a house near the plant owned by a lady who made bras, hundreds of them, left in piles everywhere a free space existed. Wild, and weird I thought. Good training for something. I the strange beast, puzzled about my fitting in to cultures I'd not ever experienced. Having never seen a bra, I was faced suddenly with such quantities!

My car then was a 1936 SS Jaguar (the company dropped 'SS' before the war), four-door, with huge headlamps I'd fallen in love with on the used car lot in Lancaster, and bought for £60. It (not she) took us to shops in Manchester, to picnics in the hills. It was slowly rotting on its wooden frame, coughing up the hills, throwing off its two-sided strapped-down hood (to the horror of my gentle Mum) as we bumped our way off the Shropshire hills to a civilized tea in the town. It lasted several trips to London, overcoming blocked fuel lines and doubtful brakes, until a pal 'in engineering' offered to fix its body. I left the Jag in a field for him to 'fix' - where it morphed into a hen house.

Poorer and maybe wiser, I acquired a 'more sensible' Morris 8, marginally smarter, definitely safer in a blunt black pre-war style. I could wind open its wind-screen and had yellow mechanical turn indicators.

Somehow through all these vicissitudes I kept an even keel without quite knowing where I was headed. I was earning. I delivered a new car to Stan our man in Scotland who promptly organized a sales visit via Loch Lomond and Inverary to Campbeltown, the southernmost point on the Mull of Kintyre. This 'Mull' stretches mile after empty sunny mile, starting a mere 40 miles out of busy Glasgow city, weaving through low hills and stunning sea views for 100 miles there and another 100 back. Scotland is famous for mists and rains but not today.

A long whole day of clear glorious Scottish coastal beauty. This fueled thoughts on becoming a salesman 'on the road' with a company car, the key to a mobile open future (I thought). Some non-sequitur!

I spent a few months 'in sales' driving the same type of tinny company car (but at last!) I had delivered, a white Standard 8. I was based in Manchester under the

calm tough guidance of Bill, an old northern hand. This led to the same work covering east London and Essex under Peter, a smooth southerner and about to be divorced. He was the second divorced person in my life after 25 years knowing none. My eyes 'came out on organ stops' working these city streets. London here I come. Opening up with a vengeance.

Moving then to the long-established company operating the cigarette and chocolate machines on the London Underground, I became the sales manager. We launched into selling the refrigerated carton milk and drinks machines my Shropshire company imported. My most interesting sale was of a carton vender to a fishmonger in London's 'East End' to sell jellied eels to his Cockney clients. It made the news! Our service people worked hard to stop the creative antics of kids poking inside to get the products to drop out as free goodies. They also dealt with chewing gum stuffed into the coin slots. Some 'public' can be gross.

We also sold newfangled American machines into canteens dispensing foods as well as drinks and 'sweets'. Ambitions soared after our food techies mated a microwave to chilled venders. We offered precooked egg and bacon breakfasts … how can this ever be? Well, they tasted good to enough people for the idea to work.

I surfed along in these new waters under a veteran catering director who lunched on bottles of whisky and packets of cigarettes. The nearest city hotel, never just 'the pub', became our focus. With emerging ulcers I survived lengthy liquid Friday lunches on Dubonnets. I became director of two public companies, British and Irish. I attended company meetings in Dublin, taken to pubs with Irish bands playing wild republican songs. Eye-opening, again, and again! I had a good time until a more hard-bitten man came in as overall director. Wake up young man! I did. I had a two-ulcer surgery. I resigned. I was head-hunted into a new job in 1969.

Life opened up further. I was introduced to 'Coverdale'.

The first thing my new boss Cyril did was to send me to a course run by Ralph (Rafe) Coverdale who became the guru of my life along with Oxford don uber-guru BBS: Bernard Babington Smith. Ralph Coverdale had become known for his team-building work in The Steel Company of Wales and in Esso.

We saw Bernard looking and listening. In our groups he paid attention to the realities of people in these working groups, really listened and looked, silently, part of the wallpaper. When he spoke, we all stopped and listened: another revelation was that after lengthy quiet observation, his few quiet words carried what we had missed, usually with serious import, and very relevant to the group's ways of working which they were aiming to 'improve'.

You either resisted this approach to life in work groups (including home/life groups), found it useful, or made it a life-changing experience. This last is what happened to me and some others. This is where I discovered 'Observation for Awareness' along with 'Experiential Learning' and the differences and links in 'Preparation, Action and Review', 'Thought as a Framework for Action' and 'Review to Improve'. Heady stuff.

I also experienced the essentials of three-level individual, team, and organizational development, working both down from senior and up from junior levels. I was hooked. My life's work: task-focused small-group development! Self-learning in groups, sharing in plenary sessions, reviewing, putting learning into new tasks. Participants and we, as observing coaches, witnessed a group's growing up. 'Self-Developing Skills'. Looking and seeing and learning, all in one! Electrifying moments. In plain sight, but hidden.

I went on to acquire Coverdale's appreciation of different 'systems' needed for different types of activity. Mechanical activity, as with 'things', needs a mechanistic system of thinking where 'cause' leads to 'effect'. Organic activity, as with people, needs an organic system where (for example) self-directed humans lead to not-always-predictable effects. He proposes two other systems needed for scientific and ethical activities.

This took me to coaching all manner of working teams, helping them include personal growth at the same time as working to 'high quality'. I passed hours watching teams discuss tasks and go to work. As external observer-coach, my job was to look and listen during the group's task, noting what individuals did and said to help. After the task, I listened to their review and to their own observer-member feedback. We ensured that they recorded key things said and done that had led them to high quality results and team-work, and what they decided to continue. These were reported in plenary sessions hearing and discussing their 'learnings'.

I spent every week for nearly two years in Coverdale courses run for British companies. This intensive training took me to deeper levels of interest in the ways people see and hear, what's going on 'under their noses' and what they missed. My interest grew in what people did with their experiences 'on the job'.

But this gets ahead of my story.

The second work my new boss gave me was to spend two weeks in America researching the growth of small oxygen-using industrial and home cutting and welding equipment and breathing oxygen for medical uses (we were a global player in industrial gases). I traveled with Frank, an experienced man with whom I started my new business learning in earnest (a steep curve): cutting and welding equipment, breathing oxygen for medical uses. Canadian robins, so crow-large and crow-black hopping in midwinter snow-white, that I couldn't see them as robins. Chicago from the heights of the Hancock building. Old Cambridge friends in Washington DC. Scrod in a waterfront sea-food restaurant in Boston. Tidewater Virginia heat, humidity.

This seemed more like the open life I wanted, strangely in an engineering-based company when I had ended 'Physics' and 'Chemistry' classes aged 13 to concentrate on languages and history. 'New Business' journeys took me also to Madrid in springtime (enormous outdoor meals, clear skies), Stuttgart (rainy forested hills), Copenhagen (indecipherable songs at the gas engineers' jolly Christmas dinner) and Brussels (in the company twin-prop plane, floating down the airport approach path between full sized jets). I looked and saw all I could.

I drove a company car converted to run on liquefied petroleum gas (LPG) from a large tank in the car's boot (or trunk if you like). Flip a switch to run on regular gas. I was after all in the Gases Division: we 'walked the talk'.

At the time of 'Watergate' I found myself in Hong Kong (HK), arriving through the tenements' laundry on that steep descent into Kai Tak. Rare Earths were the focus for us at the Canton (now Guangdong) Trade Fair. How did I ever get into this I wondered? 'Allowing myself to navigate uncomfortable places' is one answer; another is being hired by 'risk-taking' bosses.

These were the days we had to cross on foot the small creek between HK and Mainland China. My new friend knew the ropes, an 'old friend'. He stocked us with all manner of goodies to help us survive the rigors of life 'over there'. Bottles of western drinks, especially whisky. Toiletries. Smokes (a pack a day, then). The train was easy, white anti-macassars which I imagined had gone out with the Edwardians. Tall curvaceous spittoons every few yards in the halls at the Fair, accurately used, the twang of the coughed-out phlegm hitting the inside is still in my ears. Chinese medicine teaches you to clear your tubes.

Hotel room lamp shades in very basic plastic colors. Warnings to guard your belongings, yet anything in our room, including loose change, was always exactly where we had left it. One visitor was severely reprimanded by officials after 'chatting up' a maid. At every official meal our hosts poured Mai Tai into shot glasses to be downed in one. My 'old hand' friend set light to one such glassful sending up a plume of dark smoke at the table! For dinner in town we chose our duck (or other animal) living in crates under the trees to be cooked, fresh, to order!

We were never prevented from taking photos wherever we went, crowds on bikes, geese in bicycle shopping baskets, bridges over the big river, kids in schoolrooms, workers in rice paddies, water channel intersections with bamboo gates ('look, a watergate', we joked from the bus). We liked the enthusiasm of the teachers and 'barefoot doctors' we met, not being able to understand more than the interpreter told us. Educational and eye-popping all the way.

Not that I ever became any sort of 'engineer', but I liked the engineering people. I still have the heavy illustrated report my partner and I wrote to our

respective divisions after the North America trip. New challenges seemed my 'thing'. I suppose I enhanced the company business, but my thrills were the journeying and the looking-listenings. Thrills that never leave me.

'Boston Consulting Group' (BCG) five year planning methodologies took over my second three years. My company Head Office in Hammersmith (in sight of the famous bridge over the Thames under which I had rowed) called me in to help deliver with BCG a week-long training program to senior managers in all its overseas companies. We were a century-old British organization with offices and operations around the world from Canada to New Zealand by way of South Africa, Australia, India, Pakistan, Singapore, Malaysia and Hong Kong (all once colored red in British school atlases).

Away we went! This was living! Twice to each country over 1973-75, around the world!

A shiny new Jumbo 747 (in the days of BOAC, 'better on a camel' was the jibe) stopped in Nairobi on the way to Johannesburg. No high-level access ramps yet, so we stomped up and down all those steps. Security was easy so I took my photo 'shot' at the deep blue nose as I stood directly below. Our program was delivered in a picture-perfect resort, shimmering pool, thatched 'rondavel' working rooms, all the food and comfort amenities a major corporation could lay its hands on. We lunched in a century-old business club downtown, quite the London setting.

Partying one night, a local manager told an employee to 'dance for us'. Visibly discomforted, both employee and visitors, he slowly did a shuffle before escaping. Apartheid at work.

The long flight out of Africa to Australia made a fuelling stop in Mauritius, brightly oceanic and deeply green. We 'hit the deck' in Perth, landing so hard in the middle of the night that I thought we'd never get off again. 'Aussie' was another fun stay, finding hospitality, as in Africa, in formal business clubs as if we were in London, as well as at the swimming pool and the pool table at one home.

The payoff was eating Aussie steaks stuffed with oysters (carpetbaggers they called them) in the top floor restaurant of the new Sydney skyscraper, walking by the harbor with our hands on the roof tiles of the Opera House, and dining under

that sloping glass roof with down-pouring rain-shadows making swirling patterns everywhere we were sitting.

It was much the same in New Zealand. Payoff there came in the fresh clean green hills, waters and airs of the Blue and Green lakes near Rotorua where I swam in smelly volcanic waters, watched Maoris being Maori. I bought a heavy carved Tiki in kauri wood with pava shell eyes which is still on my wall looking at me.

India entered our senses through Calcutta, its masses in every street with street sweepers in saris, clean white saris in the crude crush of bodies, beasts and traffic. We again enjoyed business club 'posh' on carpet-covered lawns and were helped to go see Jaipur, Fatepur Sikri and Agra's Taj Mahal. I saw the 'Raj' in its Anglo-Indian state, the formal living inside all its informal surroundings.

I was given eyefuls of the best of another culture and history fully entered and shared over two hundred years of mixed acceptance. Being a guy from 'head office' eased the rides and workings. 'Head office' staff tend to be handled with kid gloves, so I had to peer beyond the glossy glory to find any lower truths. For whatever reason, all I experienced was great civility and courtesies.

Malaysia showed me old settlements on the coast. In Singapore I broke a little toe dancing over those two bamboo poles one crazy night-club evening before flying to Australia where the doctors had to tell me 'let it mend on its own'. Ouch!

I wrote reports garnering me two thank-you cut-glass goblets engraved with quill pens and my initials: I still have one. A generalist masquerading as a specialist business planner! Made me keep my eyes open.

At the end of 1978 I came to work for Coverdale in the USA. I looked and saw and learned more in a hurry.

In America

Discovering purposeful women on our US courses was an eye-opener. More women 'here' (US) than 'there' (UK) added energies and openness to every program we ran in the USA. Women pursued their questions and tested themselves

to exhaustion in the work we did together. Women took more risks than our UK men in trying out new ways to work, were less satisfied with lesser results, were fearless in their searching for 'improvement'. This is ten years after the 60s ended. Here I am, east coast America not industrial England. With a powerful jolt of international attitudes. I fell in love with it all.

You women looked and saw and learned a lot, quickly. You wonderfully challenged us. Thank you. We rewrote all our material, removing all reference to 'men' and 'mankind' and academic, masculine, British (or perhaps 'English') patronizing language. It was re-visioning our work inside out. Re-looking and re-seeing became a useful concept for me.

Our clients were US Federal and UN Agencies staffed by people from the wide world. We 'ran' Coverdale five-day managers' courses and a three day version for support staff. I saw strong-talking men listen, support other's proposals, follow plans they hadn't thought of, be glad when their group did well. I saw quiet men and women from cultures where authority was rarely questioned or given, take the lead, be successful, be given support by the strong.

I saw people at every level come to expect and get better and better results, in the work, in the working relationships. As individuals became confident, as groups became team-like, as leaders led, as support through listening extended the value of any idea, it became more and more exciting to be involved. Exciting people generate excitement without losing quietness and focus.

Doing my work I came across notices of jungle loss in Brazil to clear ground for beef cattle for burgers for the norteamericanos. I worked with child health specialists setting up clinics in Asian countries. I led workshops in Ivory Coast with engineers planning to avoid sensitive habitats when designing new roadways in Africa. I spent weeks in Haiti with Americans and Haitians jointly developing long range plans involving communities as far west as Les Cayes. We watched village women wearing 'Sunday best' fully repay their micro-loans. I lived through Hurricane Georges half sleeping in my hotel room closet.

I sat, feet in the rain, under the eaves of our smartly dressed Ivoirian helper's house asking me to 'see' a Pharaoh's Egyptian skull below his modern head and

close-cropped hair. I saw awareness emerging of the damage we do to our inter-connected environment that supports us and the need to reduce that damage fast, a game we have yet to win in any sustainably large way.

At a 'Common Cause' conference here in Arlington, a bonus extra jolt, I met early 'environmental' artists telling Earth's stories. Satish Kumar walked alone in the Jain tradition carrying no money from India to England and joined 'Resource' magazine as its long serving editor. David Whyte, another Yorkshireman, talked his poetry with big business leaders who now 'see' poetic dramas in a project's life. Annie Dillard described closely observed life's multiples of beauty in Appalachia. My sort of looking-seeing though far more focused.

In England I had met EF Schumacher and discussed his book 'Small is Beautiful'. I knew James Lovelock's 'Ages of Gaia'. I entered the worlds of the monk Thomas Merton, the professional listener-to-people Deborah Tannen (a continuation of BBS at Coverdale), Nancy Rosanoff's 'Intuition Works' whose workshops I ran (it does work), Neale Donald Walsh's 'Conversations with God'. I found I was already on F Scott Peck's roads less traveled from my relating to 'The Outsider' in 1960. I absorbed Carolyn Myss' 'Anatomy of the Spirit' and the ways to healing.

I had landed. I took off. All in one.

In Life

I crossed Australia on the Sydney-Perth Express, seeing rail tracks made for three gauges, triple rails on one side, and learning that Nullarbor is not an aboriginal name but Latin for 'No Tree' (those educated Victorians). We watched old man lion roll off his mate and fall asleep beside her in the Masai Mara ('just like me' a man called out). I joined a Jain wedding by shouted invitation from the hilltop party as I drove past in India. With strangers I marveled at the shining calligraphy on the mosques in the Maidan in Isfahan. Saw baby turtles hatched a moment earlier scampering for dear life over the burning sand into the Arabian Sea outside Karachi.

Standing under the wing of the 707 at Karachi airport, we all identified our bags before our flight over a painter's dried-out palette of desert mountains to Tehran. On a PanAm flight from Auckland to Papeete, I was offered drinks through the curtains of First Class from a family being flown to the funeral from an earlier PanAm crash. We live through risk-taking. Security is harder after 9/11. In my 'mind's eye' I carry all these images and more, from then into today.

An American youngster and I talked cricket (of all things!) while we landed at JFK surrounded by fire trucks chasing alongside us believing that our wheels had not fully let down. The crew of a BA Jumbo congratulated everyone at our London Heathrow landing in the thickest of thick fogs for being on the first completely 'hands-off' automated landing there. One flight to Miami was through a succession of very bumpy cumulus that had me holding my 'calm-myself-through-reading' book high off my knees so I could read anything at all.

There were years of 'white-knuckle' flights out of Washington National with my over-active brain imagining every worst scenario as we twisted our way north above the river to avoid closing on the well-protected White House. In a four-seater float plane in New Zealand's Marlborough Sounds, I was scarily scared, gripping the seat so hard it hurt but I captured a few shots I liked of water-front homesteads set deep into the 'bush'. Two helicopter rides in one year, above the Niagara Falls in brilliant sun (spectacular), and across the Grand Canyon in fuzzy visibility (also spectacular). My camera took me out of fear. The sunlight over the Falls' clouds of spray sharply shimmering bright.

I don't see myself repeating either flight. And I certainly do not need to be helicoptered out of a burning skyscraper or ship at sea (to example the worst of the worst scenario). Yet, none of these events so 'faze' me that I want to give up moving, looking, seeing, listening. Flying still thrills me, a new view of life below. Hills, trees, seas, clouds, roads, roads and rivers, farms and cities are all fresh minted from 'above'.

I also rewrote myself in ways I relate to today. I have Anglo-American eyes. I think both sides of the 'pond'. I love 'there'. I love 'here'. Whichever way I am looking, I love life. I drive (I used to drive) both ways. I prefer BBC English as

it once was. I chafe at BBC English as it once was. I admire the infusion of local speech. I find I don't quickly understand it. True in England and in America.

My chosen situations challenge me even now.

I travel for exploration and discovery around my interests. When I was traveling for work, I sought the fun, enjoyed the new and different. I speak my original English, learned at school and at home. 'Genuine English', people say to me. My Mum and Dad would I hope be proud. They would also be proud that I have networks of good friends in America (church, writing, photography, music) while I keep close to family and friendships in England from childhood, school, college and work.

I'm less sure they'd like my life-style today: loose and noisy! They lived quietly and tightly. School people don't spend unnecessarily. WWII hung a tight noose around our lives. 'Shanks' Pony' was our rule: walk! Bikes and trains and buses too were good to us. We used them well. I watched trolley bus operators in Bradford Yorkshire pull down the twin overhead trolleys, placing their wheel-ends onto new overhead lines to switch routes. In Liverpool we rode the 'Overhead Railway' (jokingly called our 'El' and 'the dockers' umbrella') and the square-ended ferries 'cross the Mersey' to have a crush on Simone Signoret in Le Casque d'Or at the risqué Birkenhead's Continental cinema.

From 1940 we lived with rationing, Food Stamps and Clothing Coupons but never traded in shady corners with 'black market' characters (widely reviled). I won a local prize aged 8 for painting a 'Dig for Victory' poster. We indeed dug in our allotments and back-yards. I was told: 'scrape your plate clean' and 'eat up the spinach' (oh dear!). We scrimped for meals until rationing ended in 1954. We bought biscuits at the one corner shop from glass-topped open 'tins'. Bottles of sarsparella. Walls' vanilla ice cream. I still wipe every last drop of soup with a chunk of bread. After cook has served the omelette, I go scrape the pan's sides for the last of the overcooked brown edges onto my plate. Scrunchy good. No waste. WWII kid at heart.

In 1952-54 I still had to go to Emmanuel College Buttery to collect my weekly 2 ounces of butter, my 8 ounces of sugar and (horror of horrors) my 2 ounces of tea.

With all we now have, only 2 ounces of tea a week is hard to believe being English! I'm accused of making my tea too weak (rationing still?) But as said before, here I am.

Everyone did their own looking and seeing. BBC radio was our life-line to the world, for news, for learning and for amusement. I'm enjoying BBC 1920-40s history in 'This is London' (the BBC call sign) by Stuart Hibberd who was the radio news announcer wearing formal evening attire (to respect his listeners) and whose voice I heard, as revered as Walter Cronkite's on US TV. I am enthralled by the BBC's Chief Foreign Correspondent John Simpson's 'Not Quite World's End', hair-raisingly dangerous adventures around the present world of wars, bribery and corruption. BBC is encoded in my bloodstream.

No TV, let alone GPS, no web, no Google, no cell phone. No phone! I had to take two heavy old pennies down to the end of the cobbled service lane behind our house in Liverpool to make a call from inside the heavy red kiosk (even my trousers were heavy, good Yorkshire wool). I pushed the A button to connect if they answered or, if not, the B button to get my two pennies back. We made route plans before we started out, and as family stayed together. We lived connected lives. We knew where we each were. I don't remember anyone panicking if we didn't.

There are today approximately three times more people living on planet Earth than when I was born. I see few people in the background of Dad's photos in his 1920s and 1930s pictures. WWI had drastically cut down our population. Gravel lanes in the Kent country near Biggin Hill (before WWII fighter planes made it famous), are empty of folk. London streets for an Arsenal soccer final are very short of crowds as we know them. There was then space in which to see details and people's faces. Much the same in my 1950s Cambridge. My school and Emma had 300-some students, not 600, let alone the 2000 at a US High School today. My ideas on looking-seeing-listening have been formed in these story-crucibles I share here.

SEEING IS BELIEVING

A hundred years ago it must have been easier to see changes and differences. My supposition is that today people often miss detail. And that missing detail is a function of the increase in population as much as it is an outcome of today's upbringing in the world of Busy and Electronic. Doesn't too much detail glaze our eyes? At the same time, detail watchers like the National Security apparatus in USA and its pal the GCHQ in England, constantly collect more and more detail about everything.

What do we do to 'see'? Focus and awareness matter. Narrow or wide. Either or both. Both, if you want to add the fire chief's 'helicopter' over-view after hands-on ground experience. Observing skills matter, seeing reality, noticing life's actualities as they happen.

Watch a mime artist working his amazements. Marcel Marceau for example. Silence, all is in your seeing. Every tiny detail is at the heart of catching the story. An eyelash moves. A finger shifts position. 'Aha!' See a movie in a language you don't know. You have only what you see. Do you see even more? Get less of the story? Get other angles of the story? The deaf live here. I know as I'm half way deaf these days.

We have more detail at our finger-tips but do we incorporate the beneficial. Do we ever 'see' it, see the whole?

If you are all 'good lookers' you already see, you look at, you like the sights you notice. You've seen and listened. You enjoy life around you, directly from

your own experience. You won't believe me when I tell you that the vacation place was so good. You have to go look, go see for yourself. See more, take in more, believe more!

A picture may be 'worth a thousand words'. Yet at the same time, 'words fail me' in trying to describe an experience. At all times then, we would do well to be alert to more than we see or say. Others' sight is as valid as ours. Intangible 'insights' are as valid. The unexpected is to be incorporated into our perception and understanding of the world and our life.

Pictures are an undivided whole in one. Each is a full message. No words. Their whole is their start into our life. A look tells all. Immediate messages. 'Doubting' Thomas had to see and touch before he could believe Jesus was with them again. Words are linear and need to be followed to the end to get the message, for it to come into our life. We look for the punch line. Still looking. Looking again.

And yes, with both, we may discern further messages with time invested in their study and discussion. Both images and sentences are for our use. The 'look telling all' is also an outcome of our eyesight, our ability and our willingness to find more when we look. And first looks lead to more lookings. To deeper, clearer. To insight beyond understanding.

So, framing the image is key to choosing the words. One is context and one is content. Framing the image and choosing the words set our expectations. My purposes, both the intentional and, as I write, the discovered, frame and choose what appears in my book of both pictures and words. It is all a cycle, a repeating, continuous, discovering cycle. Like life.

Sharing my own discoveries, I throw you the surprises and delights that opened my eyes from experiencing and for finding 'new landscapes'. The catch is my inviting you to develop 'new eyes' as I open mine further. I may never know if you 'buy' this invitation. Mutual trust? I write, you buy on a whim, you get?

This collection is offered in the hope not only that you enjoy my pictures but also that you may be encouraged to go looking more. The more you look, the further you'll see and the greater your enjoyment of going out and about. Carry a

camera. Take your sketch pads. Take paints and easels. Capture your images. Play with them so others can share your finished pleasure.

I notice how many stop to look at the painter painting. 'Getting in on the act', wanting to see what others are 'seeing' while they are 'seeing' (as they paint for example), tells me we have an inborn desire to 'see' further, to uncover our own eye-sights' blindnesses. When we let go, when we stop to be at other's places and speeds, we acknowledge that our own place and speed may mask our limitations. Try new places and speeds for eye-openings. Look through their eyes. Did you ever imagine?

This is not 'bad'. It is part of the differences we all have. 'Vive la difference' is more than between the sexes. Charles Darwin carefully recorded species' differences. We can use these differences to show us where we stand in the world. We can use these to rejoice in the diversity that is in life everywhere.

We learn and love life and its re-collecting. So my images live on in my mind long after seeing them or making them in my camera. I think of these as my galleries.

In Organizing

This collection is still arranging itself in my head (poor head). Initially I considered separate galleries (books) of differing types of images. I have my own language for these different images. When I look over my photographs I find various obvious groupings.

People and events familiar only to me and my family and friends make one group or book. Others are only familiar to people who travelled with one of the tour groups I helped create and lead. These more personal pictures I 'see' glued in and written up, as Dad did so well, into albums, white ink on black paper. Some will (or should when I am ready) become electronic files available for anyone, anywhere, or turn into more books.

There is now this mix which I consider good enough to turn into a 'gallery in a book'. These I 'see' in a variety of related groupings which first suggested gallery

(book) titles. My organizing brain 'saw' 'People Pictures', 'Countryside Pictures', 'Water Pictures', 'Mountain and Sky Pictures', 'Town Pictures'. Of course I also find many pictures covering more than one of these imagined 'tidy' groupings such as 'People in Water and Skies'.

I travelled to 'eye-opening' places that others might like to look into through my photographs: Vietnam, Haiti, the Celtic fringes of Britain in Wales, Ireland, Scotland, close to my origins. After sorting slides/transparencies I shall also 'have in view' my bits of India, Africa, New Zealand and Australia too, not to mention America, Canada and the Caribbean. I envisage topic pairs with essays such as 'People and Places: Portraits in Haiti'.

At least my output may explain what I have been doing all these years when I wander off, leave the crowd, disappear into my own worlds of picture making. I used to fire away freely with my lens. Now I put myself into position for making the one image that needs no cropping or fabricating. I also cut prints into tiny bits to make greetings cards for my own use.

Writing this book sat me in my corner chair for hours at a time. My legs and back and eyes needed breaks, needed another posture, needed more exercise. It became a race against time: complete or collapse. So here I am close to completion. Finish line in sight. Collapse avoided (but see CODA!).

My organizing brain further came up with the notion of tying all together by using a common end tag (such as Ways) to each title. 'Colorways' says much about the astonishing variety of color combinations. 'Waterways' goes from streams to oceans. 'Highways' for mountains with skies and skies alone. 'Pathways' for narrow streets and trails through grasses.

I want to stay more in my imagining right brain than the analytical left that can categorize everything out of its inherent light and life. I escaped this self-imposed dead-ending corner by using no such headings. In this book you will find a mixed medley, a crossover crowd, a messy melange, a view of every variety. This will at least allow you a holistic peek into every corner of my picture closet. It's an 'and-and' win.

Next is the format question. Surveying my picture scenery, I find vertical, portrait shaped pictures and I have horizontal, landscape pictures, both in roughly equal measure.

My organizing mind doesn't want to put you to the trouble of twisting your eyes from vertical viewing to horizontal as you go through this collection. You don't do it in galleries. I will not make you do it here. So. Simple! I am making one book of horizontal and vertical together in a square format in which I play with different photo shapes and positions. Friends say they like the mix. 'And-and' win again!

The final format question has to do with the writing. I want to write briefly about every photograph I offer you. I want to tell you something of why I wanted to take it, of what was happening around me at the moment, even afterwards. I will not refer to shutter speeds or apertures (I rarely note them).

My primary interest is the final image and the exchanges it may engender within you readers/lookers. I aim to attract you to the images regardless of explanation. My comments on the page with the images say what I like about the photograph. Why I thrill to each one. All very right brain, into artistry and beauty.

In the following section I describe how I came to take the picture; I give its context and location. Here is my logic, my left brain explanations. We benefit from both. They are, however, very 'Ian' images, like 'em or not!

All this is my knee-shaking hand-wringing brow-wiping responsibility. We have to trust each other! I have dispassionate helpers. Although it is passion that moves me to make the images in the first place, I recognize that I can be overly proud of my own opinion.

As one of my editorial friends said "It's your book, Ian: it's your choice". This book is at the same time progeny of Dad's photography and Coverdale's behavioral insights filtered through my experience in observations, photography and writing. I am keenly interested in the 'looking-seeing-listening' continuum.

After wrestling with how to 'slice and dice' the photographs producing left brain dramas, I ended with simply naming each and setting them for you in alphabetical order. I looked a long moment at each image to take it all in. Title words

came to me with no clever thinking. Very right brain and the result seems accept-able, even good. Friends like the contrast between views, shapes and sizes, titles and the irregular sequences.

Variety, much as in life, which is just as it should be.

So yes, these are some of my eye-opening experiences, illustrated. On-going thoughts added. Another editorial friend called it all 'Contemplative Seeing'. Hence my reference to Richard Rohr's writings.

My wish for you is surprise, with enjoyment of what I have to offer you.

Go see for yourselves. Explore beauty in this world.

For now, let's journey together.

IMAGES

The Gallery

After my eye-opening stories and influences and thoughts about organizing, now the photographs. I want to look with you at each image to touch on the interesting, pleasing minutiae, to find the beauty ... in the following part, I tell what I know about the moment and the setting, satisfy our desire to find out 'what' and 'where?'

This is not a test! It is my way of moving into the deeper side of 'looking-seeing'. I am interested in the way we look-see and what we make of the result. At the least I wish you joys in this journey. Then also more joys as you move onward. The images are intended not only to please you but to show how many only become things of beauty once identified and displayed. Earlier when they were not seen, they were hidden in plain sight. It took insight, mine here but yours also, beyond their mere sight to show them as pieces of fine art beauty.

Here then are some of my 'Moments of Beauty, once Hidden in Plain Sight'!

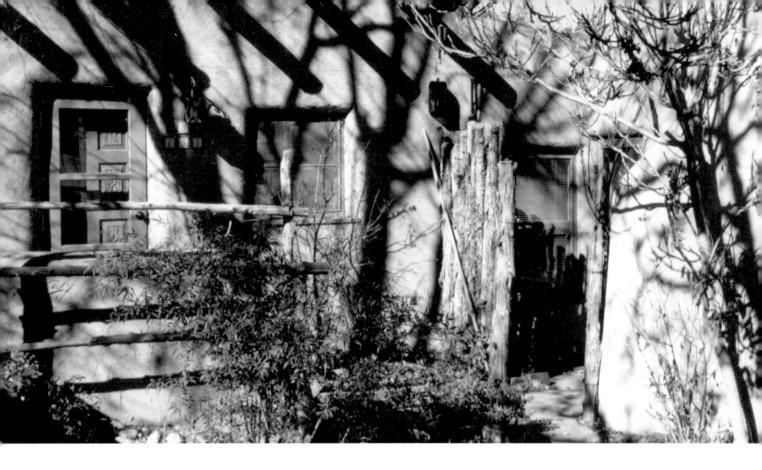

ADOBE SHADOWS

A home is enlivened by the strength of this morning's sunlight drawing pattern games on its artless walls, artless art to be noticed. Dry air, smooth adobe, rough bark, sharp twigs, soft colors, floor shadows. Fragile fronds, hard stones, straight and twisted. Observable detail.

BOAT PAINT

Old paint, old boat, what depths of color, what hints of hard work, what skills used in making then keeping her afloat, what sweat and agonies, crying out loud to be heard. Quiet, you gulls and waves.

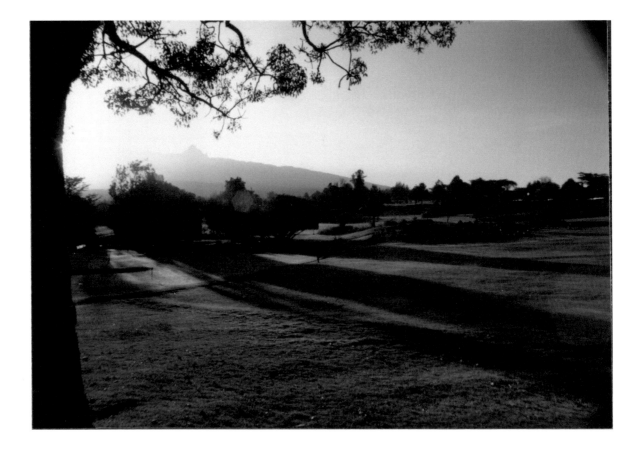

DARK LIGHT

Glaring from behind the big tree, bright strong sun pours out of a topmost stony distant peak. The green-brown lawn looks smooth and gentle on bare feet. The sun is kindly in this park-like setting. I feel the heat of a day that is yet to come. Cool of the dew remains. It is light enough for the dark to be unthreatening, easy on me. This scene's stillness allows us to enjoy it. We should be unthreatened in this early morning sun light. The big tree reaching over the shadow lines frames the image, holds it in place, keeps us in its thrall. It is master of this show. Smaller trees ahead give depths and widths, play pattern games on the grassy earthy level ground.

The central line of low trees takes my eye off to the right, meeting the downward slope from the heights, then is returned along the far right by a stroke of red dirt. This is manicured grass battling basic red earth. The patterns of lines angling our eyes make comforting shapes, steadies my heart. The green we see holds ideas of old-fashioned lawns, cooling me. Some morning cool-heat emanates from the red-brown smoothness. The mid-view tree lines hold at bay the outer threats of greater heat that shower at me from the high-ground of the sun. Overall, this red-brown ground looks oven-like.

Holding court in a way that anchors my comfort is the big tree, guardian of cool. Its small leaves let it survive the heat for me. I realize suddenly why jungles matter to people living around the middle girth of Earth. Green for more cool, more water. But here, I don't see any water 'on the loose'.

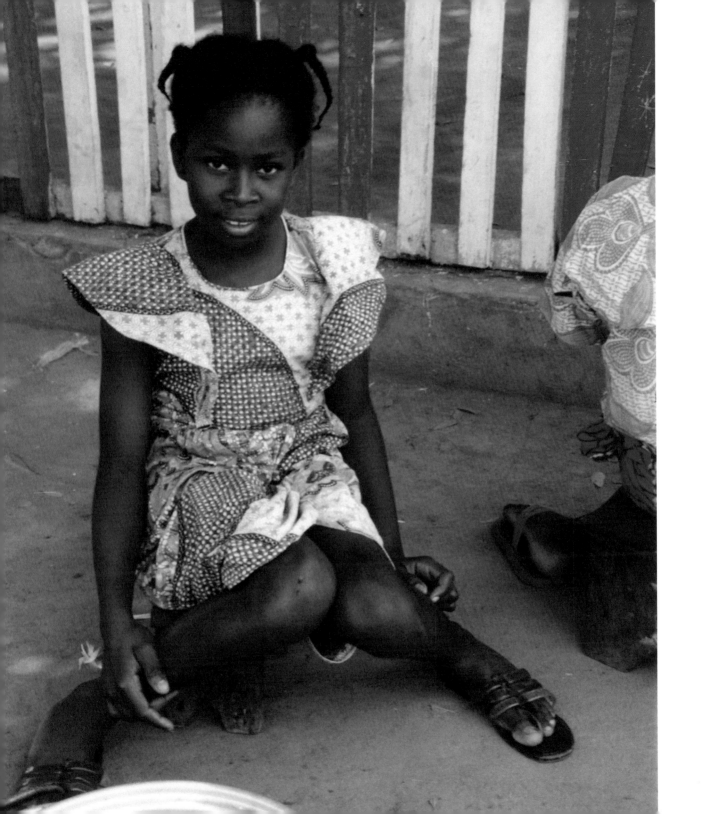

DISHWASHER

Teen or younger at the ready waiting for the next set of dishes to cleaned, returned beyond the fence to the kitchen, with more to come. Quietly easy with her job today and with this stranger pointing a 'thing' at her, directly in her face, giving a smile in return. How trusting the young can be. I'd like to assume she's well treated in her family, by café customers with tips, treats and smiles. Her clean dress, she wears good sandals, proper in front of guests: all give me hope. She may even be paid.

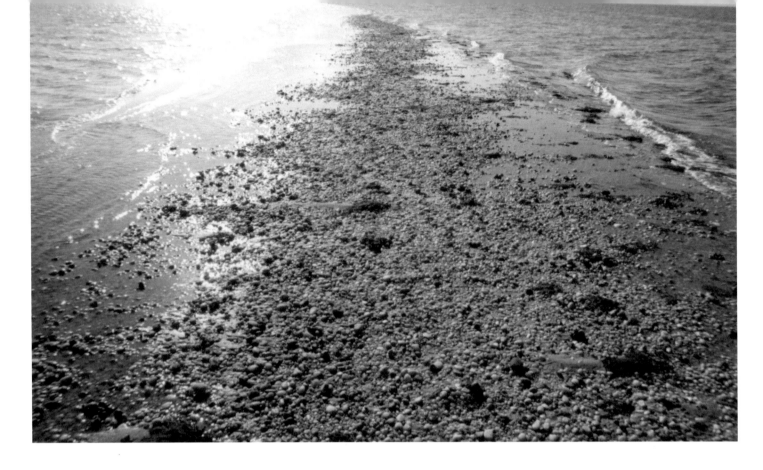

DIVIDING POINT

A point of balance, yes. These slight pebbles work hard to stay put, almost under water. Sea and stone colors married, muddy but no mud, hard enough to hold me up, divide me: to the bright tip? A place for gazing long, breathing deep, being as one, touching our source. Here humans began.

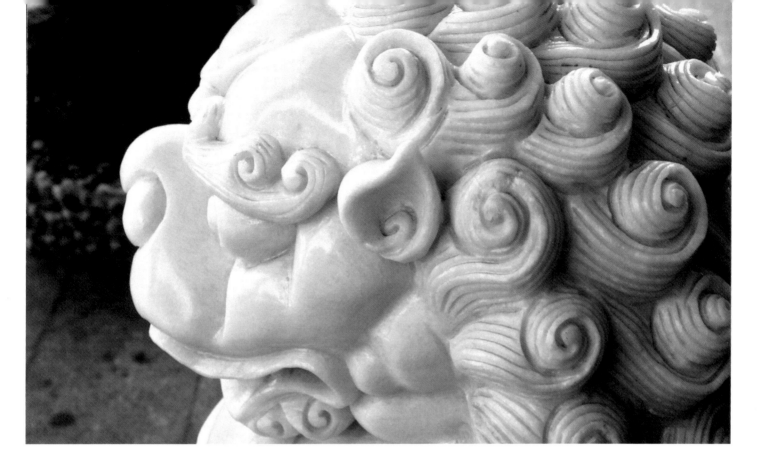

DOOR LION

Guardian of the entry steps. Marble very little polished so far. Clean shiny new marble. Look at the sheen on his cheeks and jowls. That curling snout hides a snarl. The many repeated tight curls are sharp still. See the crisp combed lines, the curling brows. For a guardian beast he's well chosen. The bulging eyes say keep clear of me. The soft lips and balding forehead may offer a friendlier greeting. Beware, yes, but sit awhile, even 'stroke me'. Maybe not risk a joke about shiny well-coiffed lions.

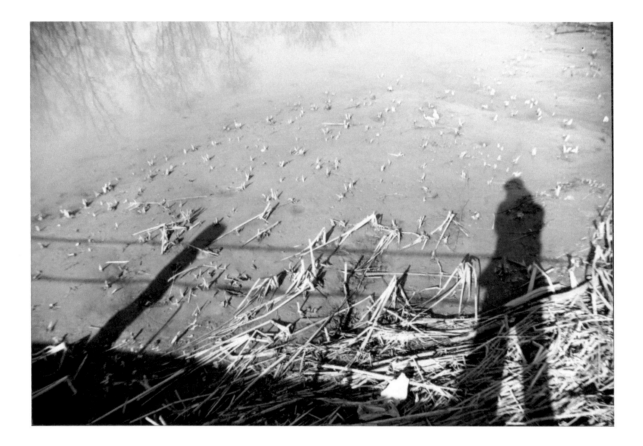

EARLY SPRING

There's a shadow on the end of the legs of the human photographer person. It seems early spring with first shoots pushing through the last of winter mud. The arch of the mud pointing into the creek is decorated by the reflected new leaves of trees at top left. The lines of the railings on the deep shadow complete the triangle begun at the shadow line at the man's feet. Most photographers don't easily appear in their own pictures without damaging the intent of the 'shoot'. This opportunity arose and was taken … an advantage to photographer and viewer. This is fertile space in which to be the artist's model, a shadow portrait, a dark silhouette, another shoot in the mud.

The wetness of the mud can be felt as much as seen. The risks of stepping in are evident. This is Nature's closest to being 'red in tooth and claw' on an organized suburban walk, here posted and railed. There is so much mud that the water must be tidal, space indeed for emerging shoots both above and below the surface.

Mud enough too for the winter-flattened reeds and cattails. I love the cross patterns made by the downed reeds, the trail's rails and posts, the man, the shoots. It could be a mad-man's crazy board game, an inverted Sistine country chapel of wet. Drab is a potent color when deployed with sun on water and below-water-life.

The rivulets showing in the top right corner tell us there is other life, beaver maybe and I imagine crabs and bugs of many hues lurking. Sun is here illuminating the start of new warmth. Man crept in to partner this life.

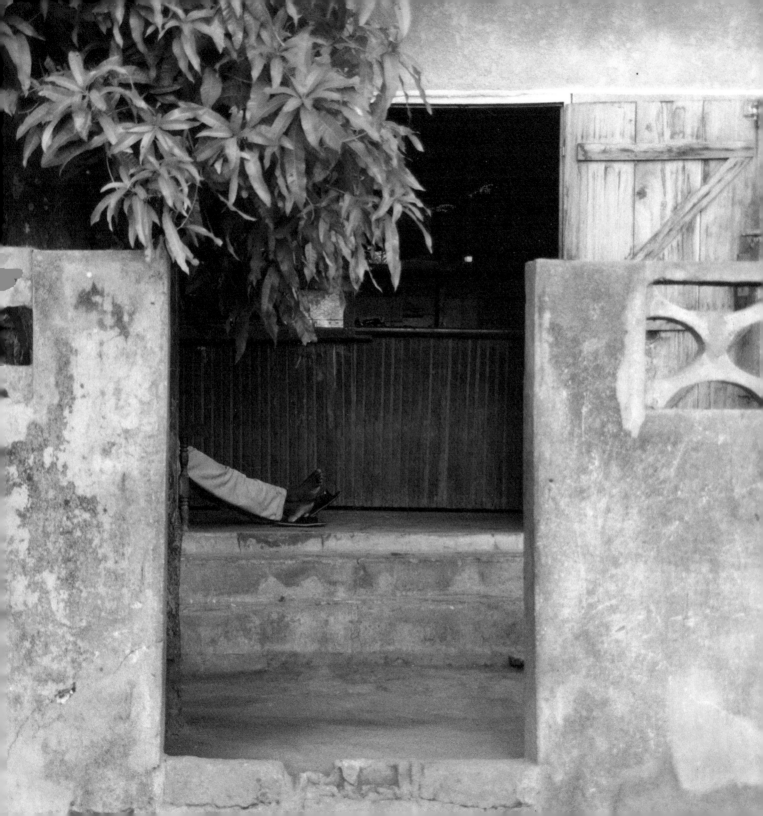

FEET RESTING

Bare feet, skinny legs, flip-flops half off, body out of sight, alone, the epitome of relaxation. A rural retreat like this, a casual bar set in a simple opening looks tidy, clean, a place I'd go into for a cold beer. The sequence of yellow-gold stone steps invites me in. The clean rectangle of the doorway is itself welcoming-pleasing. The foliage's dark green leaves provide another sign of welcome from ancient practice: tree branches set upon roof peaks saying 'building done: come in'.

There is a contrast between the unfinished concrete surfaces outside and the smooth wood of the inside bar counter invite thought about the readiness of the operation. The pink of the naked foot in flip-flops is another contrasting aspect of a bar appearing to be smart. Narrow 'stovepipe' pants and resting feet.

The floor looks swept clean. Even without any sign, there is an appearance of comfort beyond the threshold. The wooden door stands wide. Two decorative stone sections speak of a design to please.

FENCING LINES

Strong shafts of sun and shadow make my eyes blink. Sharp weavings of fence lines against lines of fallen grasses behind. Not classical chiaoscuro but a happily bright natural light-dark successor.

The head-turning angles of light and shade make my head shimmer and shake. It seems like hard winter sunlight giving the lines an edge of clarity denied us in the heat of summer. The short cross lines are so precisely at militarily right angles.

The tilt of what must be vertical fence posts is a trick from the artist's eye. Each post is properly set in the cross-bar. Each post is exactly cut, each repeating its neighbor. Do they guard a carefully maintained place? Yet the laid-low grasses beyond the uprights make me wonder why the mix of tidy and straggly.

I love the shade of blue-gray in the shadows. It's a shade you find in Impressionists' fields and gardens, below the parasols of dainty ladies and the benches they sit on. I like the white sunlight highlighting the grain under the paint on both upper and lower cross-bars and the tiny pits of miniature volcanos jumbling with the even tinier spikes of incomplete sanding (and a bite out of one below). These are decorative more than defensive, in a less military and more public-popular place. Striking enough to hang in my entrance hall at home.

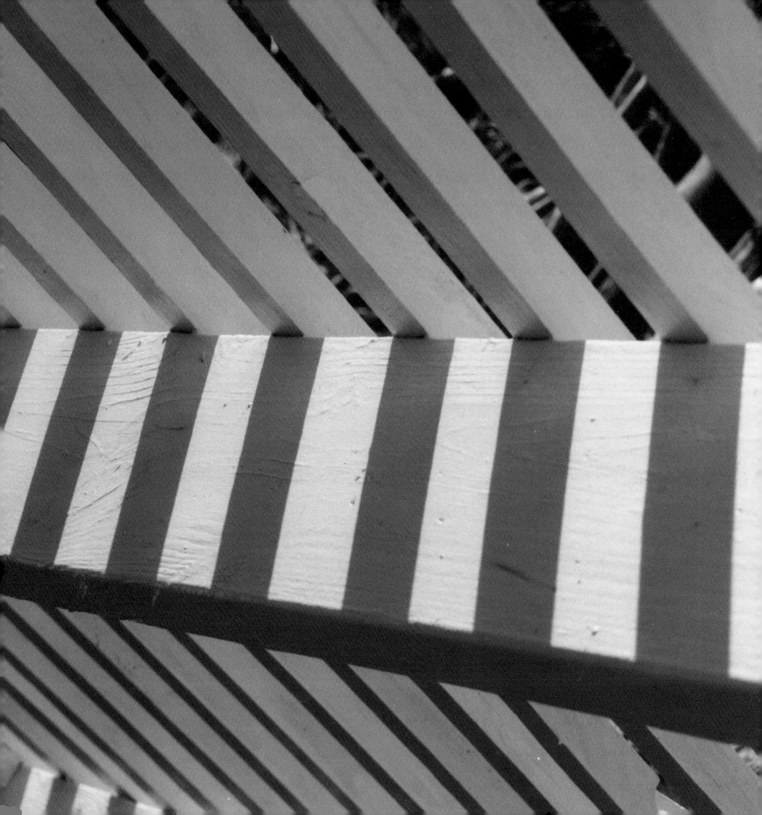

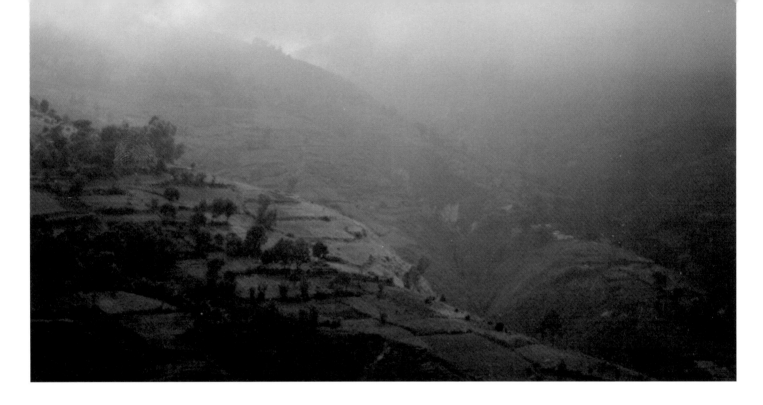

FIELD SHOULDERS

Terraces level the hills as do rice paddies in Asia. Looking at these fields makes me giddy with vertigo. How strongly green and brown with growth they are, draped over solid shoulders, 'friended' by mists and clouds. Chasms of more growth disappear while we look. Goats would do well here. It appears an emerging primordial scene.

Trees are few and securely in place which must give hope for keeping these steep slopes alive for crops and food. The lines are like painterly decoration. The faint sunlight might have been shaded by a Dutch master of interiors.

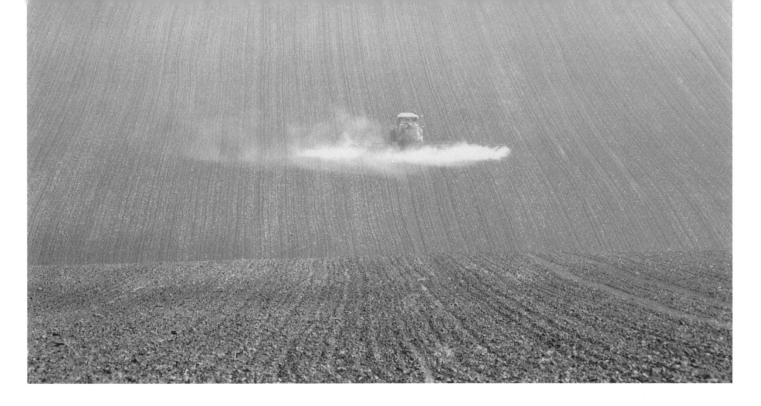

FLOATING TRACTOR

My eye caught this in a flash-past. I asked my daughter to stop, turn, give me a moment to 'shoot'. The earthy earth in its careful rows, the slow dropping slope towards the dip, the up-turn looking like linen not yet folded, all in the subtle substantial 'terra' before becoming 'cotta'.

This cross-over image makes me realize we adopt/adapt to 'now' or die. We take on the new, carry over the useful, useful at any level. Chance disruption-change.

In the end it's all socially disruptive. The farmer adopts new-fangled sprayers, grows more, better deals with crop diseases, sells/provides more, survives for another day. He shows disruption can be fun, is worth living with. Welcome to the new world while I want to lie down in the original, though there is now no original save its folk memory. Memories-stories are part of the old-new link-thread we keep. Earth to earth events. Old-new earth renewing. Life-cycling to be remembered.

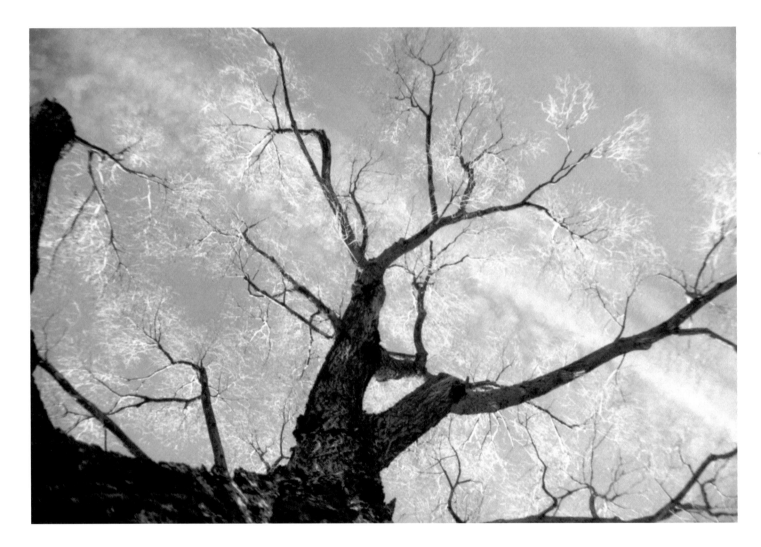

FRONDED SKYSCAPE

Dark branches lead my eye to the palest of pale fronds, frail and tethered to the tree's strength. Bluest of blue skies are scraped by vapor trails like scratch-board drawings. The high above theatrical back drop is angled across differently to the slope of the tree. I could be a hobbit emerging from earth's depths. I need to shield my eyes from such bright light.

Fronds dance without moving. My head dances without a sound. The downward sideways swoop of the image is moving. The foot and bole of the tree anchors the whole scene. Tree branches reach to touch neighboring branches, a ballet among trees. The fronds are tendrils sharing light and life. It is an elegant display of the world at work, yet producing works of art as much as working Earth. Living art in which we join, at least in our imaginations as we look around us. The direct drama of every day's sun and shade is here. Art in light.

I cannot think where else or when I might also have come across such joyful balance of dark and light, of solidity and movement, out there on the edge of the wild, clear and waiting to be seen. I guess it did exist before I set eyes on it, but in seeing and pausing to take in its glory it had never so beautifully existed. It is a silent movie with ancient actors from nature taking leading character roles. Replays occur in the Fall of every year. Free to all seers. It is one of my happiest pictures. It reminds me to try always to look both up and through the scene I see. And live with the light.

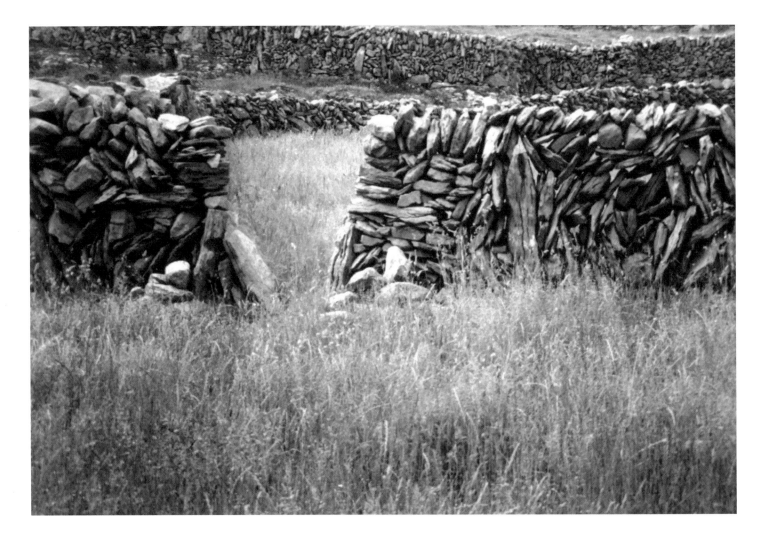

GAP WALLS

Winds blow hard and long. The gap allows beasts to get from field to field, wide enough for fat sides to slide through, narrow below for thinner animal feet. Gaps too for winds to pass without pushing down the walls.

Looking at the stones it is hard to understand the skills needed to put them together to stay in place, wind or no wind. I am used to flat stones from the fields making easier the setting of stone on stone to stay put. The jumble of so many shapes squints my eyes. My brain sees smaller and longer stones working together. They hurt my head, thinking of the hand to eye smarts the laborers have to have. Looking beyond the nearer walls, there are more walls, walls crisscrossing the hillsides, all of the same non-patterns and jumble-ness. Small short stones with long thin stones. A jigsaw of jigsaws.

I love the wind-blown field-brown grass, unkempt, happy-go-lucky. I feel it on my legs. Gone to seed are these fields of pasture. Grazing animals nibbled here, now left and gone to better grassland. Neither land nor sea gives much easily. The folk are away, perhaps forever, who once worked on and between these walls and ensured they stayed on duty. The walls and thickness of the grass are testament to the quality of hand-work they possessed which was a mark of the work their hands always did. Number the shades of brown and yellows. Count the seeds and stones. Glory to grass.

GARDEN ORB

Water from the white sprouting spout on top falls to fill four petals at the sides. The water's weight slowly pulls the inside of the petals down. At the point of fully filling, water has filled the petals to where its weight cascades back out into the pool below. Once more released, the great curved petals start to fill again, bow out and down slowly, the process repeating itself endlessly. This modern creative art work sits with people in this grotto. The whole work is a fancy playground for art and life to meet. The silver and gold and concept of the egg is rich, looked at by those not rich. It seems to be a gigantic joke. Many times larger than Faberge's royal eggs, this egg plays the same role in life for those living humbler lives, with time only to stare.

This deliberate mix of careful and crazy entertains the mind while the beauties of artifact and nature entertain the heart. The hard curves of the orb contrast startlingly with its leafy surrounds. Gold and silver combine to make a curious mix of curves. The clever kinetic nature of the artwork comes as a cunning complement to the simple waters of the pool below.

Life and Art together live in harmony for the time being. Fun in art.

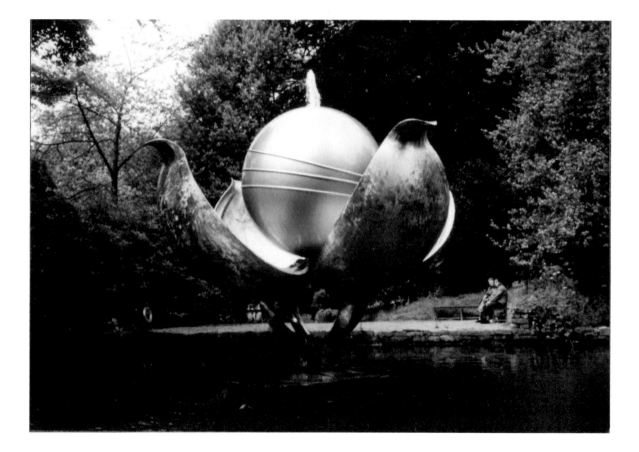

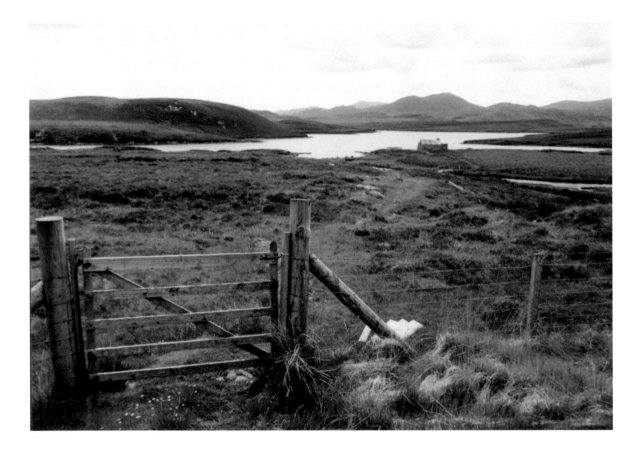

That someone lives here is a marvel of fortitude, indifference to citified society and sheer joy in having so much openness every day of your life. Quiet and nature must matter greatly to them.

Textures in the grass, the line of sight beyond the gate to the water, the low gray sky holding the hills close to the loch all attract my eye and hold my heart. At the same time, I feel winds blowing here strongly, coldly enough to keep trees down. These open spaces look like tundra. I half expect to see reindeer roaming.

Nevertheless a youthful me hankers to climb the hill and wander the water's edges. A closer look senses that a soggy boggy trail will be my reward. Arms of water spread both left and right. The well-made gate calls to be pushed open. Its two side posts look new. The track is a clearly trodden invitation. These loch-side folk may have arts of dyeing to show you using leaves, grasses, lichen and kelp that we can see, blending watery and earthy colors in a bubbling cauldron in their back yard.

The track's line of sight carries me beyond the house to the end of the loch. From the straw-yellow tufts far right runs the line crossing through the heather to the end of the hills up left. Everywhere is linked to everywhere else, hill to seas, shore to sky. Wide open spaces they may be, yet the blend of soft colors looks like a well woven tartan, ready to be put on for recognition and warmth. This land and seascape, you may tell, has been worn low by heavy ice ages as much as by people's activities.

GHOST TREE

Like a ballet dancer lifting arms to allow his ballerina a pass through to the next move, like a long-legged bird alighting on the waters beyond, this tree graces our view of the distant hills yet brings us back to the water we see. The air is still, clear, full of quiet light. Beauty lies in every angle, unassuming, asking to be 'seen'.

Whether or not 'ghost' is a respectful noun to be given, the whiteness of the trunk catches the breath as so unnatural. November, here today, is 'going to sleep' time so all as we see now will take dramatic turns for the greener over some months and hide much that is visible, certainly clothe deeply what is now naked. This is a scene I could look at for months, waiting and watching as small changes happen. I'd raise my eyes every hour to become aware of the shifts of shaping and coloring, putting on new coverings across the river, up and down the back-drop of those hills. Today the colors show as mouse-pale-brown by the river edge deepening into a foxy-brown, then into bear-browns on the pyramidal mounds, up into moose-liver-brown as the hills rise higher. All the spaces ahead and encompassing the waters are full of a moving loveliness.

I feel I am alive in each space at the same moment. Possibly just 'seeing' is to love and be alive, seeing all by itself and no more, is permissible, without penalties. 'The eyes have it'. I'd like to think so. The best I can offer are these images of openness punctuated by living nature detail, of my love and aliveness. I hope you may be blessed by such an image once in a while: 'To have and to hold'.

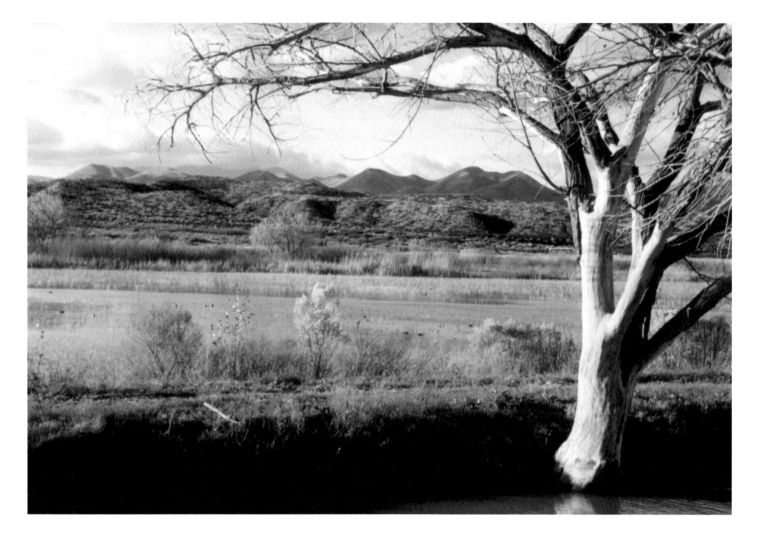

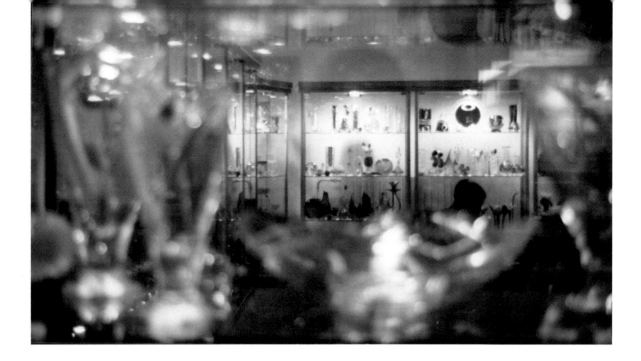

GLITTER GLASS

Touches of yellow and red along with purple and green enliven the setting with clear architectural display cases. After a minute my eyes see front and back pieces on a whole stage. The closer glass makes a theatrical proscenium for this show-play to please passers-by. The modern pieces create drama in solid color, clean lines. Rain and shine, day and night, art is given room to flourish. The artificial lighting, as in theater, polishes the glass to shine, to perform well. All together the set has become a jewel box, a theatrical show without the need for tickets. Stay, enjoy the show.

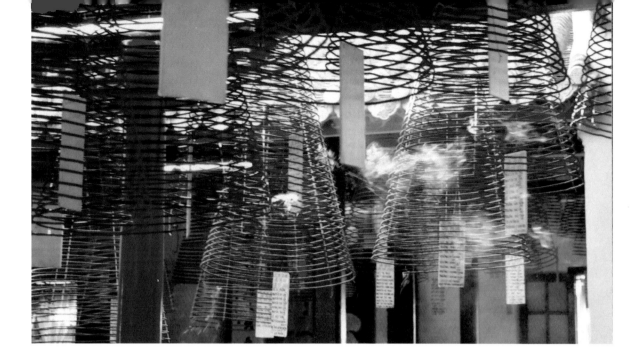

INCENSE COILS

Shape-shifting coils, mixing colors, smoking clouds, hung to be sold, seen to be liked. Eyes water in the varying light trying to make out just where each coil is in the spaces of the shop. Buyers take the coils to light at an altar sending prayer smoke upwards.

These colorful swirls imitate smoke in their shapes. Yellow panels take on the role of prayer flags like those in the mountains of Tibet. The whole shop becomes a chapel of mutual worship. Looking up and across and around become acts of worship even while money is changing hands below. It is no wonder that color plays so central a role in religious services when we are moved by secular palettes so spacious that a heaven is conjured in the here and now.

Small and large, red and yellow, fuming and still, all coils lead and light worship times. Artless and artful, commercial and spiritual, urgent human forces working together in business and prayer.

IRIS BRIGHT

Love these deep purples and be ready to be entrapped as tightly as a fly. Become a new Georgia O'Keefe work of art. Catch the light on the glow of the pollen on the stamens and wonder.

Strong patterns of white take my eye up, into, around the petals' turns and twirls. The finger-pointing middle invites me as the spider did the fly. These shapes, lines and densities are as powerful as any web. The green is a rabbit hole to below, beyond.

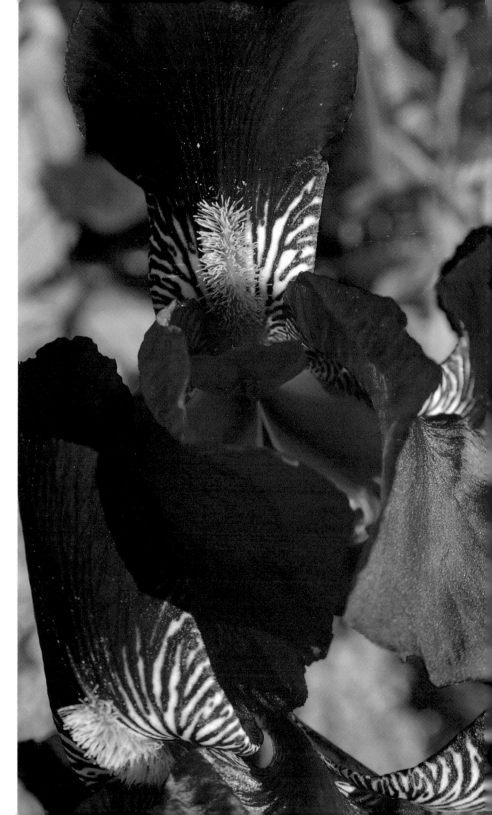

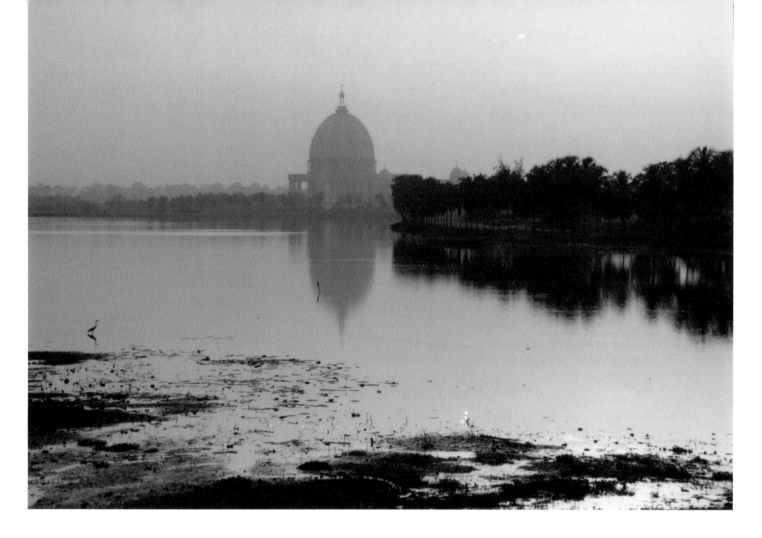

LAGOON BASILICA

Mirage moment, mud and weed-speckled water, egrets fronting heat-suf-
fused trees in one wondrous hazy water-sky elemental image. Wild displaced
Renaissance dome? Launch-pad into holy space?

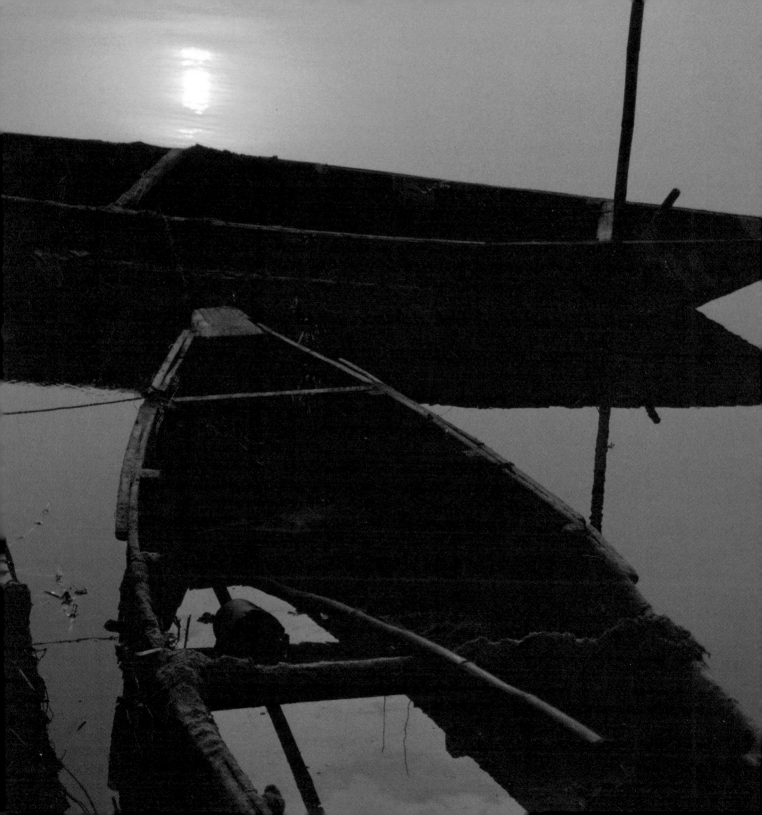

LAGUNE MORNING

Stillness among work boats. Liquid gold seems possible in a calm morning light. Is this the alchemy of a river? A moment of quiet before the day's heat and work activities.

Darkness seeps out of the wooden sides of the boats. It's a heavy light, mobile and molten. Clouds show in the water. The sun throws its early burden onto mirrored calm. The browns of a working people show in the sharp sheen and shine of surface waters and boat edges.

Laid down, silent poles belie the human efforts and noises to come in their use. The practical shape and line of every working part give us a sense of beauty in labor.

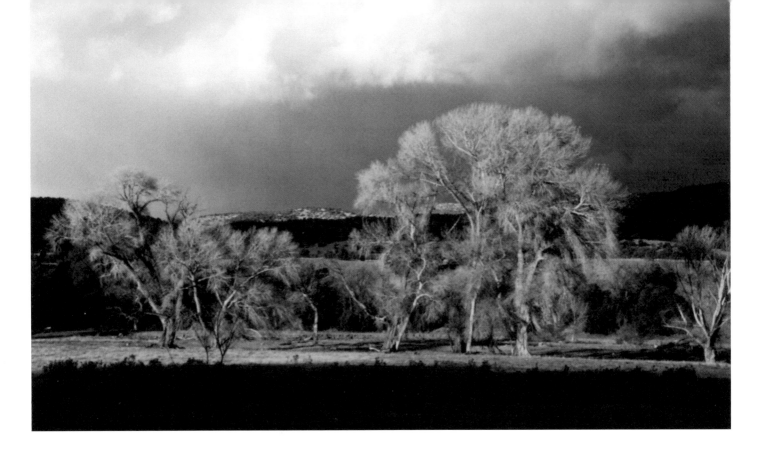

LIGHT ON DARK

Evening sun tinges the cottonwood tree-tops. Man-made theater has a hard time competing for attention when this is on hand. Gray-blue skies give depth below white clouds with a baseline of dark field shadows. Look at the levels, lines drawn between land and sky, and blazing the way across the stage comes dazzling sunlight. Beethoven and Wagner understood. They wrote for this. Both Constable and Corot could well have painted this. An end-of-day pastoral. Without the cows.

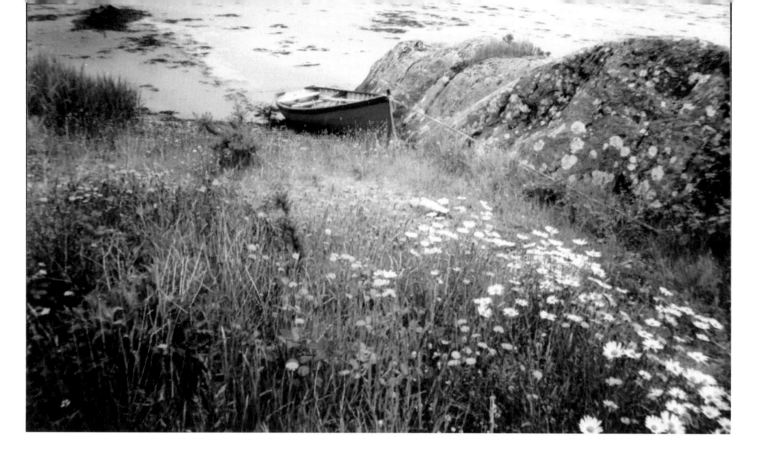

LINE BOAT FLOWERS

Center point is the red boat cradled in the mass of the rock and the earth's solidity. Diagonal lines meet on the prow of the boat. One runs past the boat into the water and weed mix. The other links the saddle in the big rock, and the huddle of grasses far left. The boat holds all: stillness of water with quiet busyness of flower heads, the lichen patterns on the rocks and the dark kelp surfacing in patches across the light water. Red boat and green line are the hard practical items in a scene of hard life in a living artistry.

LIVING ROOM WINDOW

At the end of this lounge we look out to see a jungle, minor perhaps but jungly, inhabited by birds coming to a variety of feeders hiding in the grasses. Soft sunshine streams in. This has the quiet of northern light, not southern bright.

Lilacs outside, tulips inside, seed heads in a blue glass, other glass ware, a green and a pale mauve lie at random along the shelf with a plate of homemade cakes by a small, pale brown wooden box. A chair back and arm sit ready.

It all makes a homely setting where youngsters and oldsters alike can gather. There is nothing specially arranged. Here is home, casual, friendly, not heavily organized, easy for people to come and go. The curve of the window is itself welcoming. The inside and outside floral shows make a divergent type of greeting: inside a welcome; outside uncertain messages, it's a wild barrier out there.

All the colors are muted and themselves easy to live with. There is nothing pre-arranged for visitors to admire. The whole scene stands out as a casual domestic place. A theatrical designer couldn't have selected more compatible colors on a stage where characters dressed well but not formally, walk and talk in familial sentences. The dark frontal edge gives a contrast for the hard white of the shelf. Glass squares separate the foreground domesticity from the wilder multitude of grasses, their slim lines reveal little more even as they define this space. They suggest it is better to stay on this side of the window.

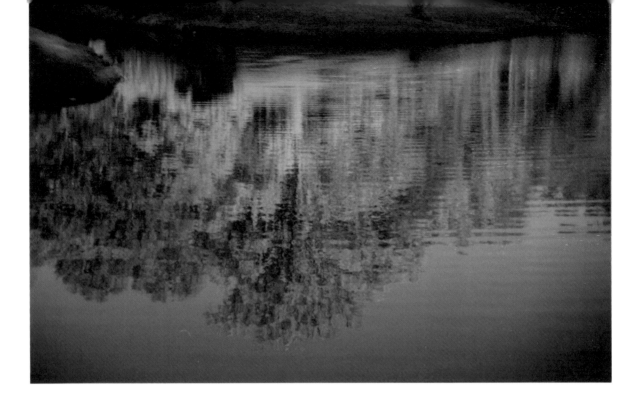

MIRROR FALL

Images ask me questions. Upside down or right side up? Glorious clear skies and deep autumnal colors look far better in large than in small format, and this way up. In a local park I took the picture both right way round and upside down. The fine panoply of northern gold and Mediterranean blue look as richly burnished as a quattrocentro painting of mixed heritage, of the Netherlands and of Italy. The gilded background is here. The Madonna's blue is here. The countryside browns are here. One art of art is to look more, further, to find art beyond the obvious of what is in front of you. Look deeper for the water shimmer to become like a violin vibrato. See the shapings in the canopy of trees, discover the interplay of shades, the palette of the artist being put to work for our pleasure.

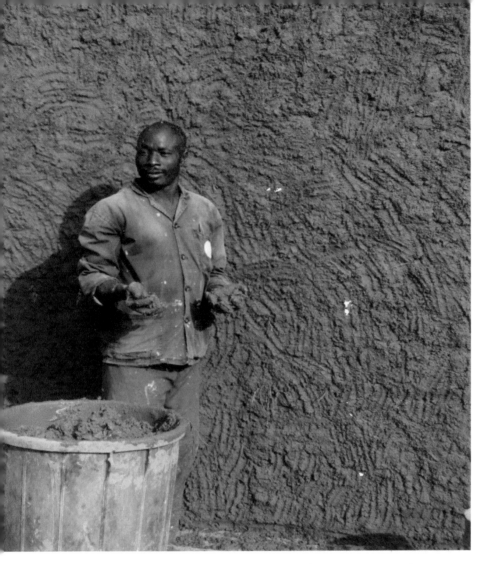

MUD PAINTER

This man, a curl of a smile emerging, seems to enjoy his central role. He has created the bed on which others come to make flower displays. His finger scratch marks make sure the mud stays in place, a structure for displays to last several days. Art in the crafting.

The sun's strength brings out the deep terra cotta of the wall's mud. When was river mud so dazzling that you had to shade your eyes? Seeing the great tub of mud waiting for art to be sprung from its loins, makes me mentally struggle to lift and move it. Strength too is in art. Think of metal sculptors, stone, marble, wood carvers.

I love the wet slew of mud in the tub, its shine and evident viscosity. Some of the strength of the art work lies in this slop, straight from a nearby river. This reminds us once again never to separate art from craft. This gem of color has remained in my mind for 20 years, as has this craftsman's relaxed proud smile. If color has a character, it is on display on this wall, in this man's hands, deep in this tub. Art in a tub.

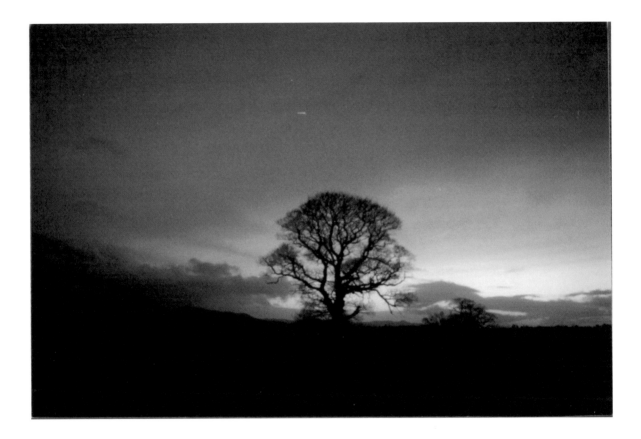

OLD SUNSET OAK

The tree for me beats the sunset colors to command the eye. A sound safe investment is an oak tree's wood after centuries of slow growth. Like slow cooking, flavors come out. Tree growth rings, close, tight, will show strong as a sunset. Sunlight goes slowly in summer, casting deep depths in the sky, as lines inside an oak.

This glow is glorious. The tree branches seem to burn in the heat of the glow. This is the burning bush writ large. The sky seems too small for this phenomenal plant, deep rooted, earth-tied, son of the soil. There it grows still, life left for more seeds to fall, the fruit of which we cannot predict. The sky's palette displays royal, imperial purple in ranges of shades to keep all emperors past, present and future in the knowledge they were once, no more, 'above'. Sky holds a grand awning above Oak Tree's head, a marriage tent. The sweep of the late sky closes the day out in a piece of grand theater.

This is an oak tree in the prime of its life. It will outlast me by centuries. It will take a disaster to fell it sooner. Oak forests across Europe have been felled to build castles, palaces, famous 'ships of the line', 'half-timbered' stately homes. Old Oak is now protected, nature's art for our pleasure.

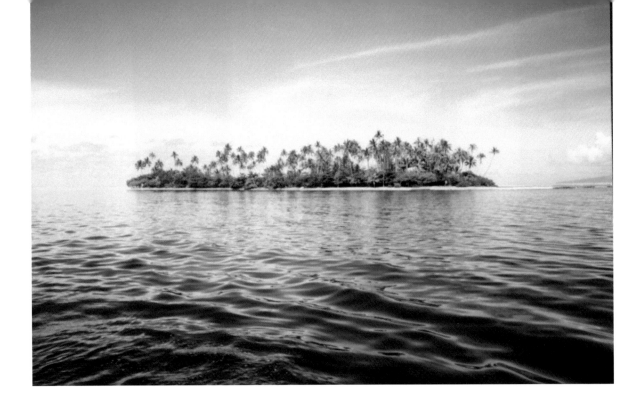

PASSING PARADISE

Whatever floats your boat needs no further answer. Try a small sailboat, take a local crew. Is this not what we yearn for in a tropical gem? No neighbors in sight. Decorative palm trees crowning a cut-out classic atoll. Back-drop of easy clouds on the horizon. Simple shores within reach. A playful spit of sand emerging on the right. Rippled sapphire waves quietly move across from left going on to top right. Activity without energy. The deep of warm waters. One distant other island. Gems.

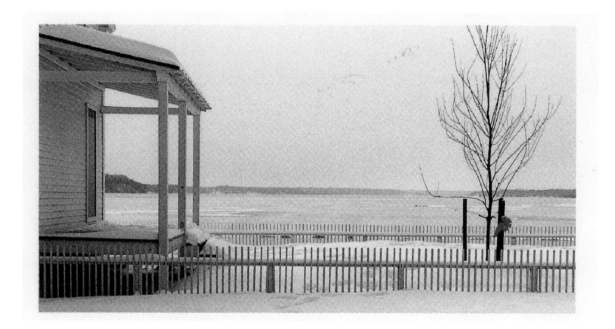

'RED BOW AT JONES POINT'

After the double snowstorm which hit first on Sunday then again Tuesday early in 1996, this serene scene caught my eye even if telling of very hard work for birds and anyone working near the Potomac River, completely frozen. The sharp red of the bow against the dark post by the naked tree balances the bulk of the old lighthouse at Jones Point at the southern end of the old town of Alexandria Virginia. The tiny upright picket fencing guarding the historic building sends its own sharp message. Anna Karenina, it's yours. This is from the post card I made of the photo I sold to a lady returning home to Denmark. The featureless sky and stark cold river fading to the distance exaggerate the sense of Siberian freeze. Can it be Washington DC, or anywhere close? Go, see: it is!

RICE CURVES

These handmade earth works hold dirt, water, young green rice and, looking older, the harvested paddies at the very top and bottom. This is human ingenuity and plain hard work on show. Elegant terraces just for food. They didn't make these terraces for my pleasure, but they do please me. Looking at the world, I see art more than 'eat' but as a historian I know something of how farmers have land-scaped our country-sides ... after all that 'hunting and gathering' on the run, we made walls, hedges, level fields, paddies, rails, roads then buildings everywhere, our settling down.

Artful, gracious, beautiful ... how else can we describe such an exhibition we in America and England might put in a gallery, charge people to see? There are dry stone walls in equally elegant curving rounded 'bee-houses' on permanent display in the East Wing of Washington DC's National Gallery, on show as 'art'. Surely too is this picture. Look at the frame of tree foliage in front, rocky creek bed behind, bright sunlight illuminating the center. The walls are at the heart of the art.

Art not so much 'composed' here as 'happened'. This is 'art' as 'seen' by us. We make this art in our heads. I framed this view to 'take home' both as a travel 'shot' and also as a piece of memory of what appeals to me. Cameras ease our seeing, finding images we 'look at' later. It is all 'art' and also craft.

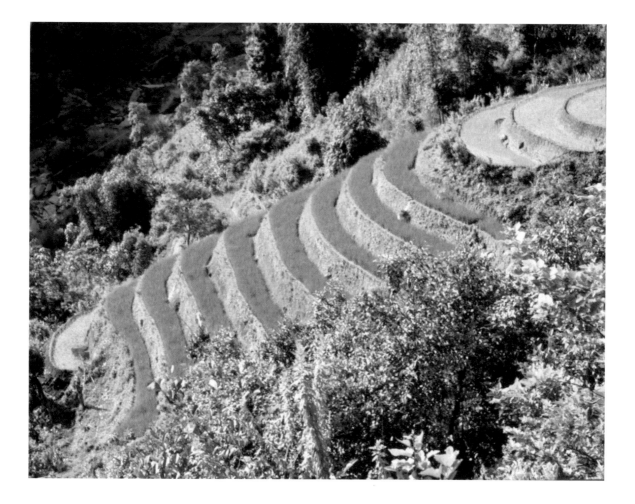

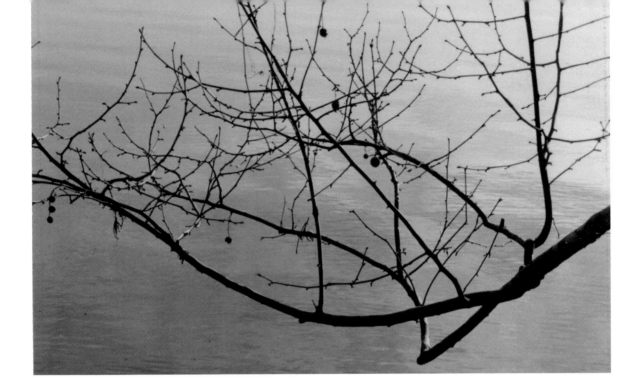

RIVER BRANCH

Naked simplicity in Nature's life. One branch among many in early springtime.

This is what eyes are for. Seeing as lovely a curve as this makes a walk a gift to living. Low light brings the water to life, gently.

Early light pinks the water. Boats passing leave low slow ripples. Thin branches conspire in an artful bow. Feel the silence above, beyond, surrounding the twigs. See the slight light catching the small branch rising from the end of the dark downward branch. Waiting for spring.

I'm glad I am not a painter, as enough patience to capture the quality here is beyond me. Maybe there's the rub. I get away easily. I just 'snap' shots like these. Or make a mountain of story out of a molehill of minutiae. My chief interest is to bring beauty to your attention. Another task is yours. Get out, go on foot. Stop driving. Having seen, gazing is a right activity. Time is extended, not 'lost' in gazing. Unexpected satisfactions are to be expected. Notice. Share. Having seen, remember.

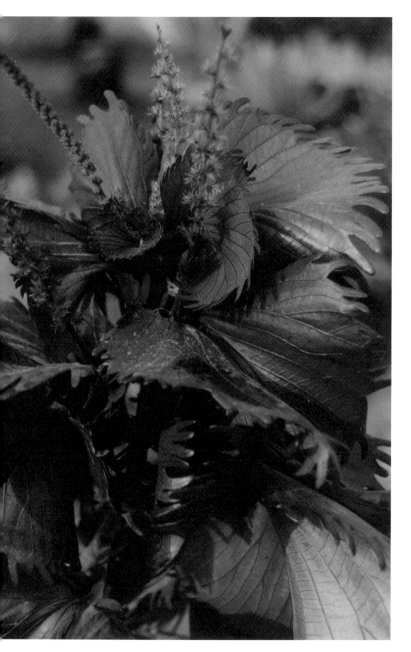

ROADSIDE FLOWERS

A mix of textures and shades casually arranged for sale on the roadside. Craft vendors in wide varieties put up sales pitches on most days, art hand in hand with craft again. The leaf veins' dark pink browns shade into skin-like flesh tones, held out as wings on a bird, fronded and webbed at its extremities.

Casual, nonchalant art, thrown together for sale while creating a beauty beyond price. All the efforts and colors of working lives show in this display, from darkest brown to palest cream, glossy to matt, noisy to quiet. Earth colors and smells, lowland damp to highland dry collect around every leaf, glossy and matte. Energies at rest for a moment.

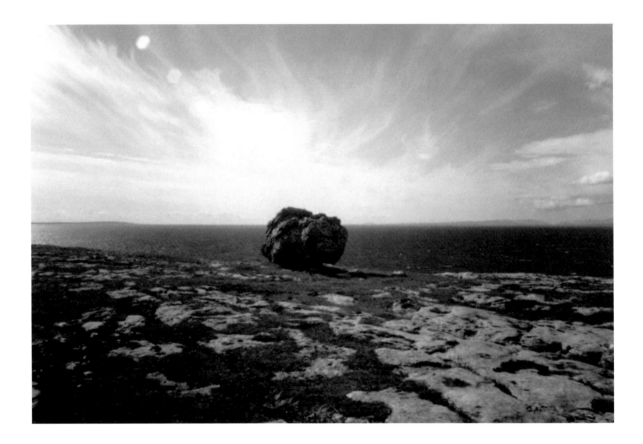

ROCK BALL

Rugged stone-brown rock contrasts with the fleeting fretwork of cloud-white in the blue sky. The ball's evident solidity hits hard up against the lacy spaces of the firmament. Nearer touchable rocks, sphere and block, hard and uncomfortable, keep our eyes on the ground. Far untouchable heavens are distant enough to ignore yet able to deliver stormy hurts. A point of balance between human life and life of the earth pivots here. Perhaps the quantum worlds which, after millennia we have just began to explore, are showing us their unstable footings.

The image itself gives us an equilibrium. In the ball is a center piece, a holding heart inside this world of stone and wind. Nevertheless, level and sloping, hard and soft, ground and air, it is an unsettling image. The picture has not been 'cropped'. This is it. The lower rock seems 'here'. The higher sky seems endlessly 'there'. That ball calls on all the gods to roll it, to shove it over the edge, to flick it away into eternity. It is the whole of our world Earth, in miniature. Do we relate to Earth like this, here? High heaven's clouds seem ready to whip us smartly off this plane into another. Crawl into the floor spaces under the little low lichens between the blocks. Safety in low places.

True! The rock floor holds countless crevices, called 'grykes', where live countless organisms, safe from winds, collecting fresh rain, the limestone blocks last resting places for old shellfish. The slanting sunlight is other-worldly. Grey stone here, blue-bright beyond. The ball, world-symbol.

ROCKS AND WAVES

The hard edges of sedimentary rocks turned over, now pointing directly at the ocean where they were born. They head straight for their midwives, the waves and deep waters. It is, in my eyes, extraordinary that ancient seas and rocks so immediately interrelate, fingers linking me, standing in the wind with the seas sending silent messages to us, we also of and from the seas. Soft people, hard rocks. Both sea-borne.

Here the world looks in the process of being re-borne.

All the way up the coast line, these repetitions of overturned sedimentary rocks in seas and winds silence our exclamations of astonishment. This is primeval land close held by these noisy winds and waves. We see blue in the sea batting at the browns of the stones. Astonishing that the sea is not more brown, that the rocks are not blue, that 'graveyards' of ships lost at sea are not more in evidence. This is what you meet if your ship 'hugs the coast'. Hugging the seas looks a better rule. 'Twixt devil and the deep blue sea'. Here it is in truth, feel it, see it, know it, beware of it. Beauty in the beast. Beauty and the beast. Extraordinary that humans are present to see and say 'How beautiful'. Soupy new volcanic land that we witness, is not such ancient upheaved sediment as this.

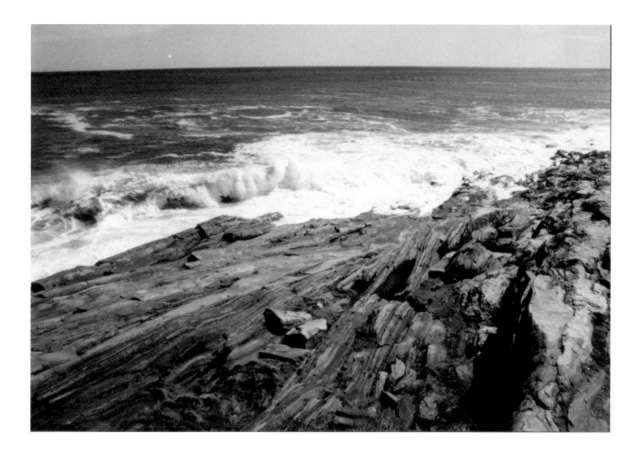

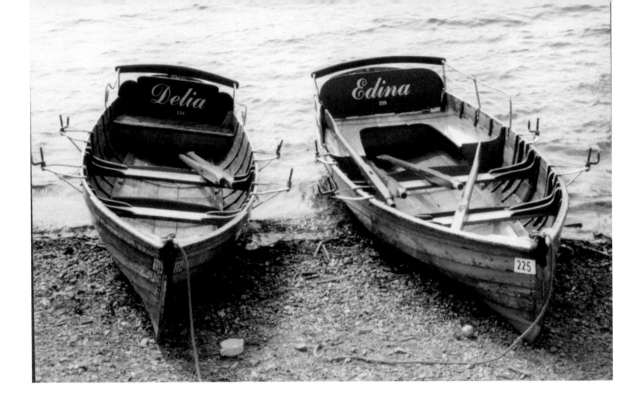

ROW BOATS

Shallow-bottomed row boats inhabit country lakes. Comfortably curved craft sit on an uncomfortable stony shore. Yet they are numbered pleasure boats, seating polished by use, moored ready for new clients. Craftsmen-built, art-at-work. Look at the oar, the turned and flat-worked handles, curves in the seats' edges, flat boarded floors, the overlapping 'clinker' sides, the hand-painted old fashioned names and calligraphy on the seat backs. Smithy-made wrought-iron work for the rowlocks. Row!

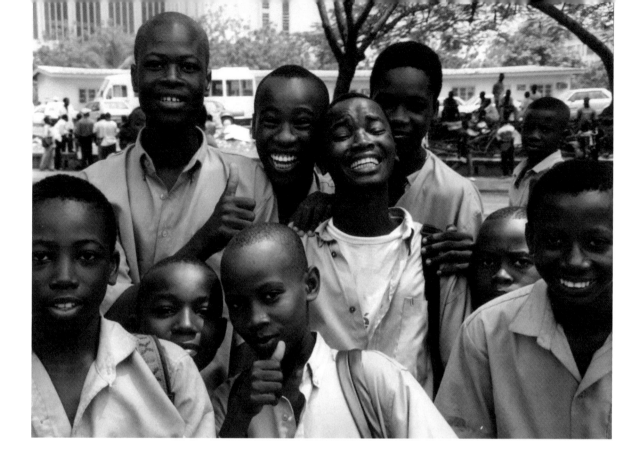

SCHOOLBOYS

Crowding together for a laugh, a lunchtime break, sun and fun, playing with a white guy with a camera, thinking they were famous, maybe hoping for time off classes. Bright blue shoulder strap, clean and shining, thumbs up! Smiles and focus on this moment, now! Quieter faces and smiles at the edges of the group. Two with huge teethy grins making a show of the event. All looking me in the eye. Showing such confidence.

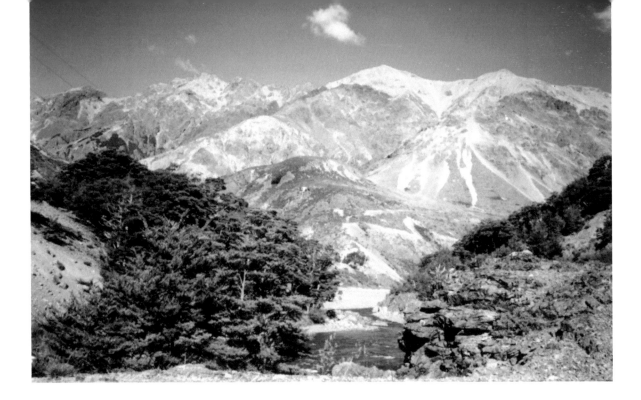

SCREES AND GREENS

This hard stony valley points the eye to the high peaks. Water flows below, with dryness everywhere on top. One bright cloud marks the mountain peak. Dry runs of scree scar the high stony hillsides. Big boulders mark the river sides in front of us. Groups of colorful trees meet as they tumble to the green creek. An opening for eyes to pass unhindered to the peak, satisfying, unreachable, sight-lines.

SIDE STREAM

Gold glints on the late last leaves before they fall. Hints of gold also color the buildings after centuries of use. Sun washes these downstream waters. On this side stream from the main river, we see quiet drama in a row of buildings.

Each has its own face, its own place, its own color in a city with history, each with its own colors glimpsing stories to be told. Gold above and silver below in the sun on the stream making this a city of lights as you move into open river views. Trees are part of the architecture. Walking lets me see the detail of window shapes and sizes. A slow pace allows me time to look again, pictures to hold, time to stop, to think. Why the ledge along the footing of the first two buildings?

Streams are symbols of journeying, metaphors for going beyond, looking to see the world over the hill. The distance the water already traveled plus the distance to the edge of the image glistening in front of me are enticements to go further. Flowing waters bear me forward in my heart, carry my dreams towards their fruition, clean my old thoughts, flush in new ones. More gold and light please!

SILVER AND PURPLE

The dark stays out of sight. Ribbing and spotting on the leaves are illuminated into silver stepping stones. Edges coming together appear stitched. Purple buds angle to be noticed, lightened by green-brown in the stems. Heads dance discreetly away from us. Yin and Yang both live in this pool.

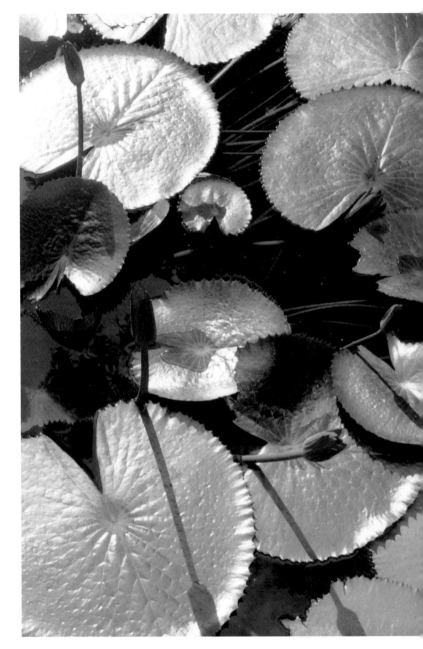

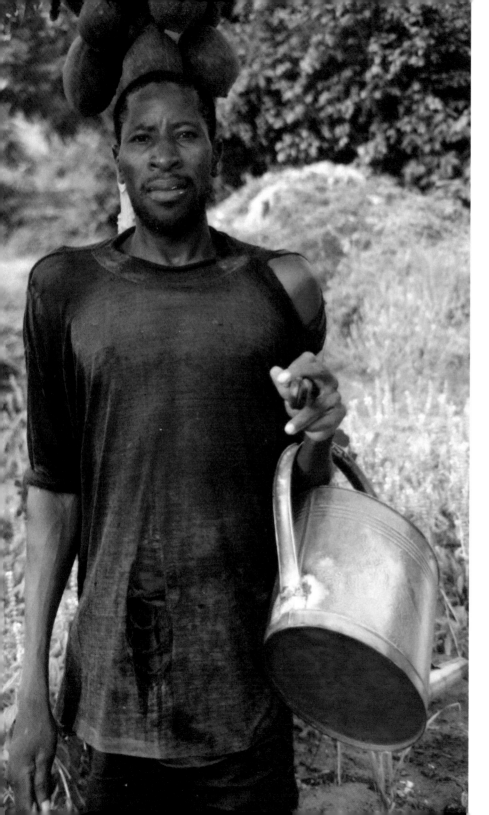

SOLDIER GARDENER

This fine man readily agreed to be in my photograph just as he was. Tall, shoulders hard back, equipment at the ready tucked in tight under one arm as though he had a rifle, not a watering can and machete. Thread-bare shirt may be worn like this every day forever. He looks me in the eye, no hesitation in confronting a stranger. A look that's half friendly lets me be willing to spend time knowing him better. Pawpaws as his crown waiting for him to cut. Knife, can, hands and fingernails all clean at the day's beginning. I would want him on my side at start and finish.

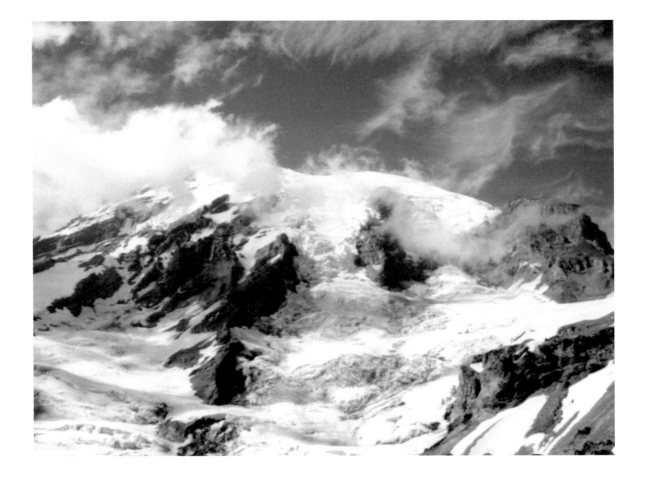

SNOWBOUND FASTNESS

High cold clouds scud by the white cold rocks. A sight line falls from a clear snow saddle directly into our lap. It crosses the line moving us from far right to far left below the rocks. A difficult snow maze of ways traversing this high mix of peaks may make 'wow' routes for braver extreme climbers than makes sense to me.

The solidity of this great mountain's heart is set out for all to see and feel. See the curves of summit snow. Is this not the very visual definition of a 'massif'? Everest seems as daunting but this view makes the vast opportunity here to be on the far edge of thinkable. I sympathize with Mallory of Everest fame wanting to climb the impossible 'because it's there'. Look up, calculate workable routes, feel your boots on the grass, the pull of the slope on the muscles, the gradual appearance of views, the feel of a wind that won't let up, the pause at a windbreak rock, the sting on the face of rain beginning, the great grand view from the top, or even the mist that fools your expectations at the last minute, all make the hills a pounding experience of the heart, not least the coming down. This picture and 'doing it', tell some of that.

Search these rocks for people or wild animals, you see nothing. Scan the snows for movement, you see only clouds gathering. Snowfall roughness along that one vertical line suggests old movements you'd want to avoid. No Himalaya, yet a pile to be taken with respect and a mountain of courage.

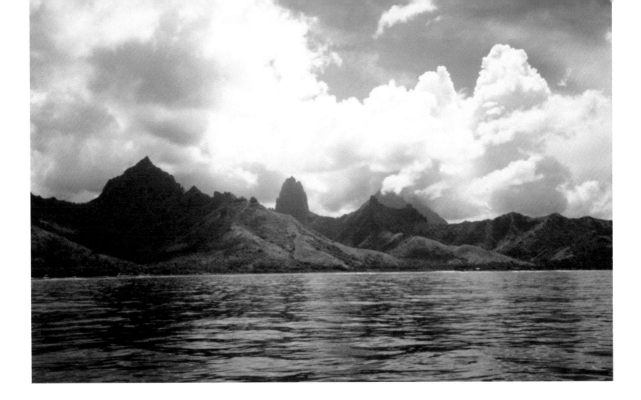

SOUTH SEAS

Waters and skies held apart by broken peaks and continuous vegetation, the island is a sky-draped drama. Blue waters invite me in, green hillsides ask me to wander, clouds in gray-white mixes just say wonder. Smooth wavelet-sea counters rougher mountain twists and turns capped by huge cloud mountains. Deep dark concaves add their excitements to the peaks and crests. A pristine scene. No buildings. No people. Natural colors. Original, not man-made. A matching mix of shades.

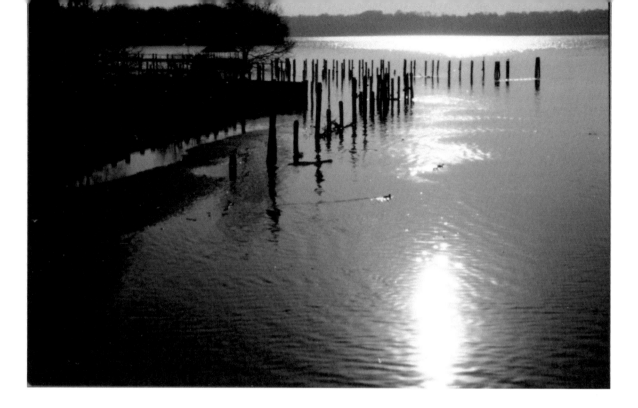

STAVES BRIGHT LIGHTS

Daily dramas of morning sun bring sharpness to the vanishing night. Two ducks paddle away to join others in the main stream beyond. The small sandbank grows into a grand crescent if I wait for the tide to fall. Sharp upright staves call for softer evening shadows. Both ends of the day warrant a stop here to look. Moving waters are balm to my soul, uplift to my heart, challenge to my eyes. Here can be winter-white lonely and summer-green lively. Here is where I fish, for beauty, for open eyes.

SUSSEX FLY SAXON CHURCH

This fly thought to sit still in the sun for the second or two of my 'shot'. The terra cotta of the tile seeps into the gray of the lichen, deepens in the shadows, colors the flaked pale pools of damaged tile, adds old tone to the differently red lower tile. Nature's air-borne lichen-life give it full luster. The wings of Fly sharpen with shine a small point of the scene. Tiny detail throws thought to the structure: tile roof needs tile to overlap tile, exactly. Fly sits above the chasm of construction.

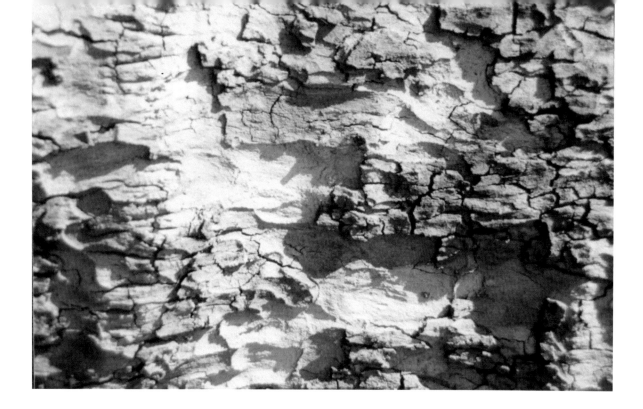

TREE BARK GRAY

Bark patterns make intriguing designs. Fabrics, clothing emerge as I look at the trees, wilderness too. This is an upright tree pitched on its side to 'see' and exaggerate the flow of patterns. Peering as from an airplane, my eye roves the cracks and crevices. Fault lines, cracked ridges, desert plains. Empty canyons, high buttes. As you walk by, what do you see in trees? An insect, one tree or the forest?

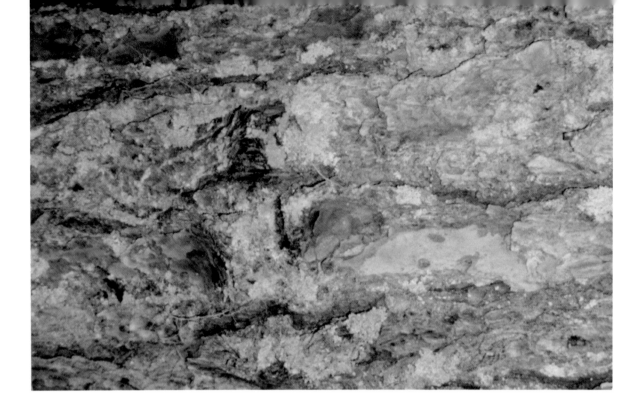

TREE BARK JADE

Rough Chinoiserie in this tree trunk makes me look, look again. I want to rub my hands over a fabric like this covering seating in a modern room, or as well in an antique room. It may be an abstracted photo yet has the very feel of real. I sense a bark's smooth roughness. The varyingly surfaced jade, overlaid, encrusted, intertwined with a chef's mix of browns, chicken-skin pale to burned-chestnut enrich an already fine surface. A William Morris hands-on demonstration. See trees sideways!

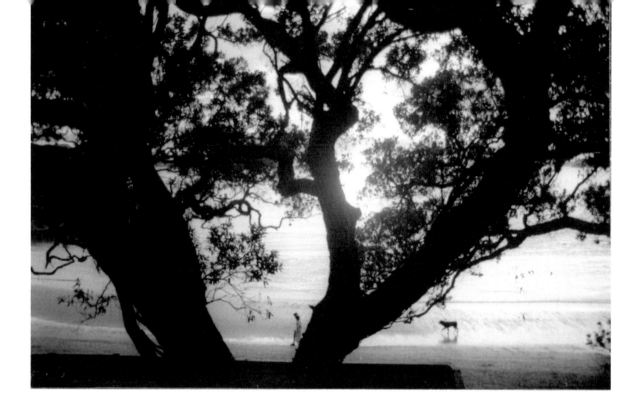

TREES AT SEA

Sun rises across an ocean. Friends and dog walk a beach. Two great trees watch as they have for ages. The density of tree branches and silhouette of leaves creates a blockade, a shield in a pattern. The trunks are of unequal thickness. The thicker blocks, giving short shrift to light. In dividing, the thinner makes the shape of a heart for the sunshine decorated by a light fretwork to carry the light to us. The tree twosome dances slowly. Nature is showing humankind how to stretch life beautifully.

TWO TREE CHAIR

A wind ripples the waters ahead in our line of sight. Evening sun falls on the birch trees' sides, top twigs entangle sea rocks. Two big rocks anchor the trees, mark the edges of this quiet place, hold us seated there.

Mossy green in the grass, metal blue in the water, gray-green in the spurt of wind ruffled water, young cream in the sunlight, old blood in the side shoots of the birches, bleach white chair side, old gold in the grass, air cured stones. Breathe the airs as they come at you. A place of presence.

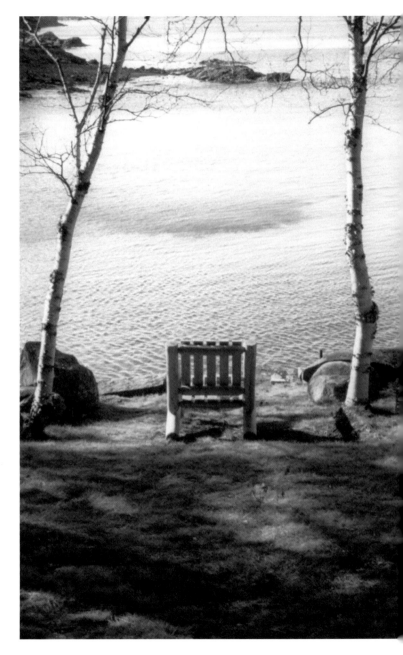

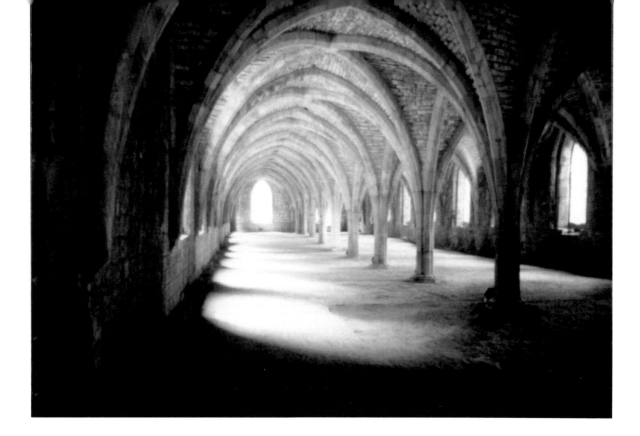

UNDERCROFT ARCHES

 I marvel at the beauty and substance of these empty arches built to hold up, a floor above, still greater glories of architecture. Between each arch, stone 'bricks' hold the ceiling in place. Sunlight transforms this 'downstairs' floor into mesmerizing space. Columns look like poplar trees lining French highways.

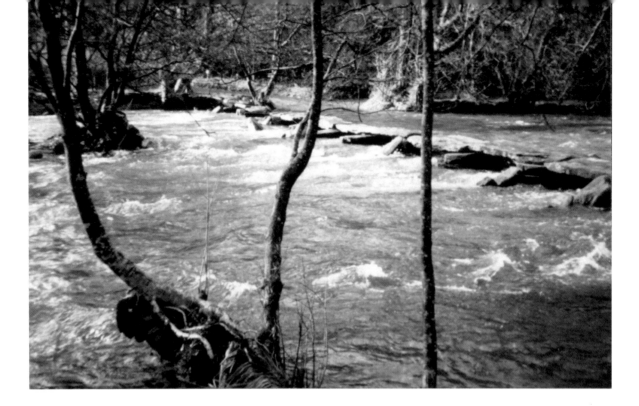

WALKING STONES

What rushing waters dash below the low flat stones! How do slender trees footed in the same stream hold their places? The midstream trees gather strength from each other huddled against the sharp shallow flood. The closest trees are so thin they'd be called 'undernourished' if they were kids. Light from the far center carries a brightness that outshines the darkness of the thick woods beyond. There is something Arthurian about a scene like this. Mystical king and his knights might ride out as we look. Are thin trees old lances waiting to be reused? Are there unicorns about to burst from the bushes? Merlin me to safety please. Hand me Excalibur!

While the stepping stones indicate people come this way, no-one is here. Only nature runs this way. The tangled web of vegetation matches the tumbling mass of white waves. Short spurts of white water in front make the dark stream seem deeper. Even in the sunny way ahead, the sharp contrast with dark water and forest suggests an uncertain ride to the castles of our destiny. Stay close, Merlin.

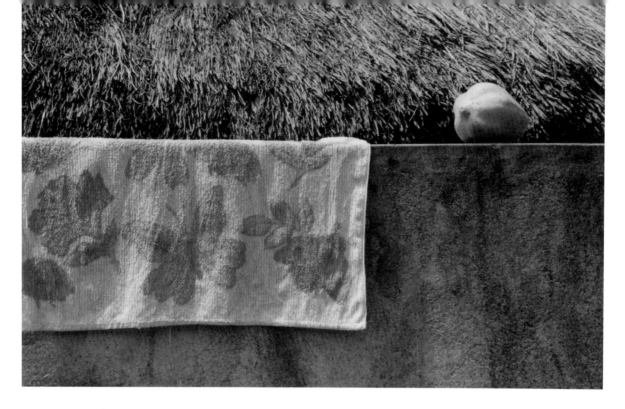

WALL DÉCOR

Look at how the light across the towel makes more patterns even into the strands of straw covering the roof and the concrete face of the wall. How extraordinary that the mango so well matches the towel. The surface textures of towel and concrete match each other. The muted colors together mass into a wholeness. The stillness, the solidity along with the movement brought in on the light's flow mesmerizes me. Might Gaugin have wanted to paint this if a few Tahitian women had been here?

A fully abstract image, one of few I take. Puzzles ask me 'What is this?' and 'What am I looking at?' make me think. Light at the heart of them, as here, make me think more.

Early morning sun shines in the heart of this image of not much save tiny specks, motes in my eye in the light.

No mirror here, the waters make their own new images each time water comes and goes. It's an image I'm not sure will make a picture to hang until I do. Surface marks etch other patterns affecting the flow of my eye. My head moves with that flotsam. That white hole with its double, acts as a focus for meditation, candle-like, holding me.

Clouds pattern the palette. Light and shadow go on a slant, diagonally crossing the picture. The textures of the creek's surface shift in subtle ways while you look, reminding us that 'looking' takes time. Casual speedy passing glances have their instant places in our seeing. Longer-looking looks add depth. They validate the glances' products and memories. I wonder at this mirror-look water with fuzzy values. Thumb marks on my glass. Wet paint laid on by fingers. Moving introspections.

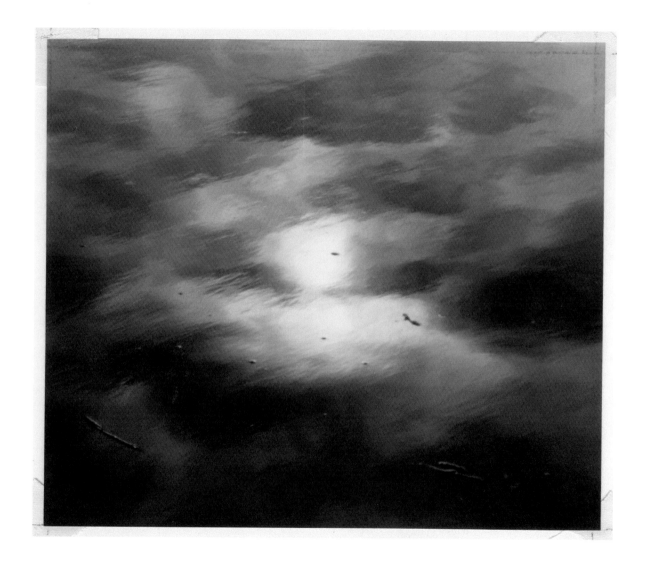

WHITE ON GREEN

The tension and balance in play arrives gently by way of the colors. Meadow green with cowslip yellow. Our lines of sight meet at the dark stone looking like a hole. From the wall of stone one line starts down to meet the horse's rump. A thin trail parallels the wall base line, making a double line. A yellow axis of flowers in the light on the grass touches all lines. Nature's greens and yellows make a soothing palette. Holding all together is the horse, stocky, steady, staring, a looking horse.

WINDOW BLIND

Through this front window, beyond the blind, a green lawn backlights the white uprights of the window frame. A dark wrought iron garden bench's curved back sits to the left. A cool afternoon sun dusts the blind with gold. There is no strong blinding sunshine. Tulip flower-heads take on an Amsterdam fine art museum-like glow, burnished brown. Pale fabric is held by curved loops along the slim bar. Mauve flower heads add a natural color behind the bench back. Outside creeps inside, cheating the blind. Inside feels more welcoming.

As a device to merge the one side with the other, the color patterns are perfectly put together. They partner well, harmoniously. They match easily, as in a quilting match, a tapestry match. Soft colors in hard framing lines. A soft-hard inter-netting of shadowy shades.

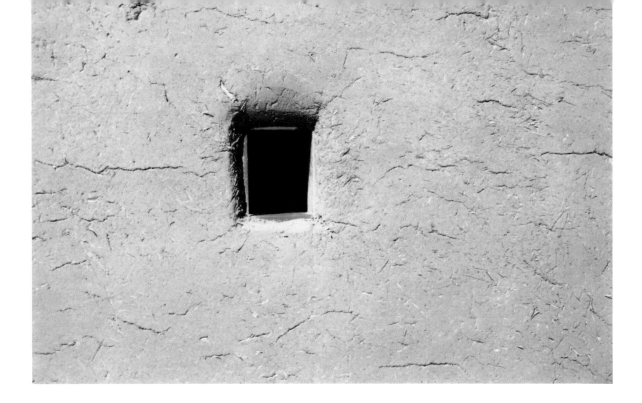

WINDOW WALL

Hard sun-dried mud gives homes thick walls, tiny windows, a sense of being steeped like tea in my tea pot. Here is an eye inside looking out, from interior cool-dark. So skin-like, so snake, so lizard, that a house can disappear into the land. People and nature working together. Cunningly. This hole is environmentally friendly, a happy house-window. A tea-pot window. Tea and sympathy.

IMAGE INFORMATION

Having teased you by not revealing the location while you were looking at the photographs, I now give in. Images are between pages 36 and 108.

I know how focused I can be on a picture's location and not its characteristic qualities. I asked you to start with the image alone. Primarily to ask you to see what you can see. I see 'see' to mean more than 'look'. That's a lot of 'seeings' but that is what I asked you here for! You put your heart into my images.

Heart led the way. Now please, run your head around my explanations.

Where I Found Each Image

ADOBE SHADOWS is in Galisteo, New Mexico USA, near Santa Fe. We stayed the night here with an old work colleague and his singer wife. I had never been anywhere near such a high desert village. Nor in such a casual relaxed style of living, seeming perfectly natural and right. Very civilized, I remember thinking. Roads in the township were dirt tracks. Night street lighting was minimal. We had to search several streets and call my friend before we were sure we were going to knock at the correct front door. The night sky was crystal clear and chilly even in the morning. In the morning light this front view struck me as special. The bright sun made such play with so many shadows across the adobe face. I think I'd enjoy

living in an adobe home. The vigas or bigas, the beams, continue across the ceilings inside and are integral to the strength of an adobe building.

BOAT PAINT, this fishing boat rests on the sands at Grand Bassam outside Abidjan Ivory Coast just above crashing waves. Its thickened old paint is encrusted with salt water from fishing the Atlantic edges of Ghana and Ivory Coast. The top colors identify a Ghanaian craft. Men working the fishing boats, off-loading the catch from this working craft, contrast with crowds of weekending townspeople who like the thatched holiday cabins in shaded places away from the beach activity under groves of acacia and Aussie eucalypts and casuarinas. The townies however, are not so removed from their roots that their womenfolk would ever miss these at-the-waves-edge shore-line opportunities to bargain for the freshest fish tipped from boat onto sand. Women do all the market trading, manage the cash flows, and lose badly when a fire consumes all their cash squirreled away in bags under their stands in the market (an event reported on the day I last left Abidjan). The old boat's colors bring back the heat of the shore and the random nature of life's business and pleasures on this fringe of life. Many coats of paint, signs of mending, newer wood above older, never-ending improvisations to keep themselves safe heading to sea day after day, working from the next country down the coast from here.

DARK LIGHT is at the Mount Kenya Safari Club in Kenya just north of the equator. We stayed a couple of nights at the recommendation of friends living in Nairobi. Our room was in a stone cabin looking at this view. We met other guests and ate in an expansive colonial style building. One morning we joined an old Kikuyu guide to drive up the dirt road towards the summit of the mountain. At about 15,000 feet we got out to walk as far as we felt able, my doctors having cautioned me against over exercising. We saw a scampering pair of baby leopards ahead as we drove. The beasts shot away so we never had clear view. However, we found their little scratchy pug marks at the road side. The guide was friendly enough in our talking going back down to our Land Rover as to present me with the elephant tail hair bracelet he was wearing, a signal honor between equals in his tribe. It still

lies, a prized memory, on my bedroom chest of drawers. We went on to have days at Little Governor's Camp, a remote but luxury tented site facing a water hole, beyond a stream we crossed in a small boat. Our tracker guide and driver found us every one of the 'big five' to boast about, bouncing across smoothly rough savannah grassland following both human and animal action. Watching people intently follow the antics of dad lion making love to his partner is quite as absorbing as watching the beasts, and at times far more amusing. As a special finale we attended the black tie premiere of 'Out of Africa' in Nairobi (from real to reel).

DISHWASHER girl works at a street café in Yamoussoukro Ivory Coast. We had shared a lunch of prawns which our Ivoirian friend consumed whole, crushing the shells vigorously between a substantial set of teeth, a table manner I had not experienced before. I happily ate the freshest fish and local mixes of veggies and meats outdoors under trees downtown in Abidjan at night, below these simple sheltering roofs beside light casual passing traffic, and in more formal dressy restaurants downtown. I took the girl to be a young pre-teen member of the café owners' family. She sits washing up while we eat close beside her. She seems comfortable working away so close to busily eating, talking strangers and responded as easily to my asking for a picture. We had just this one exchange of words, with courtesy not enquiry, and a pleasing moment.

DIVIDING POINT is on Long Island, New York USA towards its eastern end. We had explored vistas and vineyards finally finding this place for a walk. Breezy and brisk describe the weather which you see at work in the photograph. The walk had a distinct end point as you can see. 'So far and no further' you might say.

DOOR LION is at the entrance to a new hotel in Nha Trang, Vietnam one block from the sandy shore of the China Sea. In a 'homeland' group with our Vietnamese children we spent two weeks visiting four adopted families' birth places between the Mekong delta and Saigon (Ho Chi Minh City), Sapa in the northern mountains, and Hanoi. Swimming in the sea at dawn was our special treat here. Another was to watch orphan kids play music on instruments we'd brought, the first they

could call their own. In the delta we saw the same joy with wind instruments in an orphanage for the blind. Our group's gifts, brought shrink-wrapped from America in planes' cargo holds, made this happen: Washington DC to San Francisco to Hong Kong to Saigon to Nha Trang. The clarinets, guitars, saxophones, flutes, once delivered, were played in concert in the shade of the orphanage library-school.

EARLY SPRING is by Hog Gut on the Mount Vernon Trail in Belle Haven, a pair of miles south of Alexandria Virginia USA. Among other small creeks and marshes this is part of the preservation area of Dyke Marsh. Swept into and out again by three-feet tidal flows, it also is visited on occasion by deeply damaging hurricanes, even the odd tornado and in 2012 a derecho, screwing everything but in a straight line. Winds and flooding take this walkway off its footings, and also sail boats and cruisers off their moorings in the nearby marina. Bald eagles nest and fish in the Potomac River alongside this point, with ospreys, great blue herons, cormorants, many geese and duck. It is too on the eastern seaboard flyway for thousands of migrating species from raptors to songbirds. We walk here and the next 6 miles to George Washington's home at Mount Vernon.

FEET RESTING is a small bar in the countryside in Yamassoukro, capital city of the Ivory Coast. I discovered the bar walking near the hotel where we trained engineers of the African Development Bank to make their plans environmentally sensitive (curve the new road round the nature reserve!). A former president wanting to elevate this village of his birth into a city of more substance, built a divided highway here, all 200 miles from the coast. Now our fifteen level hotel towers over thin savannah. Rectangular modern government buildings proliferate between simple low homes and roadside businesses: 'hair-cut here', 'electrician service', 'baker' (using French flour, 'blé francais véritable'). I bought his 'véritable' baguettes daily on my walk, eating one on my way. Everyone greeted this skinny white man properly, 'bon jour m'sieur', street sweeper girls and truck drivers alike. Crocodiles half tamed by their keeper lived in a pool close to the President's old home, now a palace behind walls, gates and guards. Long distance trucks gathered for daily trips towards northern deserts. Nearby gathered traders, too many

to count in the noisy market souk. I pushed between body-wide tent-covered passages overflowing with every sort of fresh and packaged food, clothing and plastic inventions worth a dime to some-one. The basilica dome (see 'Lagoon Basilica') loomed across marshy swamp waters. Treasures and trinkets. Dust and drama. Cans of drinks, shell-on shrimp eaten whole. Outdoors everything. Tall street lamps light the three lane highway into the heart of a once-upon-a time village. Dogs and piles of unused building material. High overhead, our clean-managed, uniform-serviced day and night retreat from reality in the 15 story hotel with full conference facilities, concrete, marble, plush, spacious. We ate on the top floor looking down toward the bars and hidden feet in a countryside of that other world in far-away nearby. Irregularly shaped green fields, some small as house yards, gave shape to my walking routes. I used narrow tracks the width of my shoe on low dirt walls holding a higher plot. A rough and ready Eden, lovely, in transition mood, old and new closely rubbing shoulders.

FENCING LINES surround the 1865 Jones Point Lighthouse at the southernmost end of Alexandria Virginia USA. This exact point is the bottom of the original diamond shape of the capital of the USA, the District of Columbia, the DC in Washington DC. Sharp sun made me start at this clarity of lines. Two feet beyond the fence there sits under river water the original marker stone. A half dozen other such stones remain along the diamond's sides, the nearest also being in Alexandria. This fence guards a most historic location for all Americans: the lighthouse, the marker stone and the back story. Landowners in both Maryland and Virginia were persuaded to surrender a part of their heritage so that America could have a (still non-voting) federal capital city. Luckily for Virginians the Feds decided they could manage without the Virginian land. Today Virginia owns down to the low water level of the Potomac River with DC owning everything east into the city. Fencing Lines is in a public park entered below the new 12 lane version of the I-95 Woodrow Wilson Bridge. It spans the river with one opening bascule, reducing to possibly only 50 times a year the need to shut this major local and equally major Interstate highway for shipping. Voting rights, bridges and politics are tradeoffs.

FIELD SHOULDERS is high above Port au Prince, capital of Haiti. I drive up from the sea level city through the well-to-do shops and hotels of Pétionville, keep going across uneven pavement until I emerge at an abandoned wide-open concrete fortress played in by a bunch of soccer-mad boys. This is what I saw when I turned to look south. Hurricanes come here, it seems yearly, doing damage to farming and the availability to provide enough of anything. Looking here it seems also that there can be enough usable land even as you see how hard it must be. But just looking, you can never see all of the constraints working against full delivery to everyone. Costs and cuts, deals and damage, roads and reliable trucks. Gut wrenching energy fuels the daily effort for survival. Yet I still saw more smiles and creativity and compassion and art and color than I felt I had a right to expect. The poorest put on their best to pay back loans made to trade. Astonishingly beautiful paintings are stacked like cordwood for sale in an old mansion with deep porticos. Someone had worked hard to organize, to paint, in a fruitful tradition of inventive and well-made art. I have three at home.

FLOATING TRACTOR is a field south of Broadway in Gloucestershire England. In the hills on a back road wide enough for one at a time, we were coming from Burford. After a night in an ancient well-kept inn we were holding to our own long-held desires to stay off all highways and find the hidden places (in full view when you look). It needs split-second eyesight and a generous driver willing to turn-about, to go back, to look further and allow a mad enthusiast to stop all car movement so he can take a picture. No signs will tell you when to turn and stop. Usually you stop where you wish. As the saying goes 'It's a free world out there'. Choice is a fine thing. Take it if you can.

FRONDED SKYSCAPE is a glance skywards walking the trails in Bandolier National Park close to Los Alamos, New Mexico USA. This is another happenstance moment that captures my eye and heart in one sudden moment. It is far from hidden yet it is easily passed by unnoticed. First, I had a catching eye open. Second, I made the time last long enough catch this. I do this to please myself first. Then I choose to throw the image out to the world. Fly into Albuquerque, drive

northwards, hew close to the Rio Grande, then west into Bandolier. Walk the Park trail, up into cave houses. Eyes open.

GAP WALLS are on Inisheer, one of the three Aran Isles, lying immediately off the coast of Ireland, west of Doolin, south of Galway. We crossed by a sturdy working boat from Doolin in a half hour of easy but choppy water, not always the case on these Atlantic-wide western edges of Europe. A guy in a hat driving a pony and trap with a door at the back, his 'jaunty', took us riding for an hour of very Irish chat and stories in breezy sunshine. We met folk who wanted though in sadness to get away to the mainland. We met others recently returned, too sad to stay away longer from these hospitable music-filled Irish homelands in their far west, a mix of loving people, lonely lives and distant histories. More, many more walls crisscross the island, all built in this 'off-the-wall' un-designed crafty manner. Prehistoric stone ruins scatter the land. It is windy-wild lovely, ancient, remote.

GARDEN ORB sits at the highest point of the Chatsworth House gardens in Derbyshire England. One of the grandest 'stately homes' in the country, it sits on the southeast edges of the Pennine hills, wild Scotland northwards, industrial midlands to the south. This modern creation strikes a new note into a classical multi-roomed main house filled to its ceilings with museum-loads of worthy paintings and carvings. Its acres of English parkland, a 'graveyard' lying over earlier work, include the village of Edensor, home to many employees, removed twice to take it out of sight from the grand house. Paxton built glass houses (long gone), models for the Crystal Palace in London, (once home to Victoria and Albert's 1851 Great Exhibition, also long gone). Formal gardens in the French style were pushed aside for Capability Brown's English rolling parkland. Remaining is the unique 1700 Great Cascade and the near 300 feet Great Fountain. This sculpture fountain is a clever novelty, to be loved, and maybe one day moved out. Glorious, and a cultural graveyard. Really hidden.

GATE LOCH HOUSE is on the Isle of Lewis, the Outer Hebrides, a far outreach of Britain, next stop America. Salmon farms, dark rectangles of confinement, show

on the lochs' surface waters driving down the east coast. Loch Seaforth shows here how deeply waters indent the land. It feels a tentative existence, waters left, right and ahead with winds blowing us left and right. We walked too on strikingly Caribbean colored sands coming back up the Isle of Harris' west coast. Few people are about, little activity is evident, a blessed retreat. An old tour guide friend, showing us the sights wanted to come back from Dundee to the island Celtic culture in the house he, his wife and 2 children live in not far from the 'big city' of Stornoway. Sundays, disciplined by the 'Wee Free' church, is a day of closed down business so that we had to work to find one restaurant open at 6pm, a small Indian shop, facing the port. Only recently has ferry service to Scotland been allowed to run on Sundays. It was like northern England in my childhood, very quiet, no distractions. Traditional crofts, long thin strips of land down to the sea edge, still provide much fresh food. I bought a warm jacket of heavy Harris Tweed. We saw in a bubbling backyard cauldron cloth being dyed from local kelp, lichen, grasses and leaves. Scots are scattered across the world, in capital cities, in Ireland, even in Sassenach England. They are clan proud and like Harris tweed, close knit.

GHOST TREE sits by the bank of the Rio Grande at the edge of the Bosque del Apache in New Mexico USA. Sand cranes migrate south to winter here from their summer living far to the north. We watched them rise and fall in small flocks above these waters, long necks, great wingspans overlapping in the sun. This is another mystical natural corner of the world. Yet not far to the east are the White Sands Proving Grounds (really white I saw from a plane) where the first atomic 'Trinity' tests took place. It's a long way from anywhere but stays strong in my memory, quiet, sunny, spacious in November. Critical spaces for long-ranging birds.

GLITTER GLASS is a small shop at the end of the Charles Bridge below the Cathedral and Castle in Prague, Czech Republic. You have to drop down from the bridge level into a maze of old buildings in one of which, visible from the bridge, is this store. Czech glass has been renowned for centuries and today makes outstanding new designs re-using old skills in cutting, coloring and designing. We bought several pieces in one shopping, finding gifts we could give proudly and

inexpensively. This place was not thronged with tourists in 2000, a pretty and good starting point for exploring on level ground the Vltava left bank treasures of rescued buildings and riverside park walks. See 'Side Stream' which runs close by here, as does the long walk up to the Castle heights for sweeping over-city views. All Prague is a glittering mix of small and large sights: hidden pieces all in plain view.

INCENSE COILS is another small shop but in the heat and central heart of Saigon, Vietnam. It is next to a small temple and altar where the coils were set and lit. Women more than men did the buying and lighting. Men hung back while women enjoyed a good chat and gossip, or so it seemed, as I don't understand the language especially spoken at speed. The comfortable ease with which we lanky white people were allowed to slip in and out of perhaps private ceremonies was remarkable. The more so since they had suffered at least as much as we in a war, in their words, of 'American Aggression'. Most elderly carried a careful face, a cautious attitude, a thoughtful stance. The young were headed fast into their versions of a Western world of Fast - food (bowls of noodles), traffic (scooters en masse), travel (the latest Vietnam Air Airbus) but with well-blended services of smiles and gentle courtesies (airline attendants in perfectly tailored colorful ao dais).

IRIS BRIGHT lives in the garden of my family in Hertfordshire, north of London England. It might as easily be living in thousands of other English gardens. Iris have been transplanted everywhere English have moved to live. Go to Christchurch on South Island New Zealand, from where air force and explorer flights go to the Antarctic, far from Iris' homelands in Persia. Many English cities hold summer long flower shows and 'open garden' schemes to raise money for good causes, from repairing medieval church towers to sending sick kids to Disneyland. The international trade is huge and ancient in flower roots, flower bulbs, seeds and whole stems or bunches of flowers. It has bust stock markets after booms as far back as the 17th century Dutch tulip mania. Grand house owners and serious intellectual organizations invested in sending hardy explorer scientists to Himalayan heights, Amazon jungles, Borneo swamps, collecting boxfuls and discovering

117

native peoples' knowledge. The prime purpose was to return with specimens for breeding. Interview your friendly garden center owners today. Visit results at Hatfield House of John Tradescant's pioneering efforts. Go see the full story in the Garden Museum next door to Lambeth Palace, opposite the Houses of Parliament, one bridge up-river from Big Ben.

LAGOON BASILICA is the grandest piece of Yamoussoukro's reinvention as the capital of Ivory Coast. Created to magnify the country's reputation as a forward-thinking Europe-connected African nation within the Francophone region, it is an unusual and beautiful building, an African St Peter's, way out of Rome. I was lucky to be there over the Easter festivities when thousands filled the place to overflowing. Local 'kings' wearing ceremonial black cloth berets studded with gold pieces (we are next door to Ghana, once named the 'Gold Coast') mingled with prelates and parishioners, in push chairs, in teen casual, in adult French styled finery, in the specialty polished cotton dresses (famous from Abidjan to Paris). Singing and swaying, mixing tribal with traditional church melodies and chants, the music also filled the round heart of the building, behind rich colored-glass windows, held together within grand columns and carvings. At the huge exit doors, I came across women looking in, babies on back, large groups coming and going up and down the curving stairs, driving in and out in great limos on the triple-width highway. From this central drum of a church, two great Vatican-style rows of massive columns in curving arms of welcome stretched away left and right. At their ends stood buildings for offices and guest quarters, equally classical in design as the church itself. This image I took from the busy commerce of the market gives a sense of place much more of the African savannah in which Ivory Coast exists. The Michelin regional map shows Ivory Coast in green too far north considering (said a local friend) the encroaching northern dryness from beyond the distant Niger River and the Sahara deserts. 'It should be more brown-colored, like Mali'.

LAGUNE MORNING is a point on the morning walk I took from the Golfe Hotel outside Abidjan, Ivory Coast's commercial port. For USAID and African Development Bank meetings I stayed here before, midway, and at the end of the

three months I worked 200 miles away in the capital Yamoussoukro. Up early to beat the heat, I walked as brisk a walk as I could, given my high levels of curiosity and a camera on my shoulder. A level black top, it followed the edges of the waters inland from the port and the sea beyond. On the lagoon side (lagoon, lagune, take your pick in a French-invested country) were what I call 'allotments', growing a medley of market garden veggies. On the opposite side of the road were stands selling flowers, loose and in containers. Enough wealth was available to sell potted palms, ficus, vines and a city-rich complement of house and apartment greenery. I thought I also saw 'weed' among the veggie plots. Likely enough with the array of westerners working in Abidjan, a city of itinerants, entertainers, newspaper stands full of papers from Europe's capital cities, French city buses, smart dress shops, costly BMWs, Citroens and their likes. Home décor had some priorities in town. This working end of the walk was muddy but not trashy, with a half dozen men shoveling wet sand into these boats. I am not a clever photographer. I don't keep detailed records of exposures, apertures, and times. I rely on my eye for a 'sight' I can 'frame', an image I'm happy to mount, to hang in a show, to sell. I 'look' ahead. So here is the mix of sun and mist and soft-sharp edges exhibiting all of Africa's brown atmosphere that I caught, pleasing me. It 'gets' some of the hot humidity of the morning an hour maybe after sun-up a few degrees south of the equator on the west coast bulge of Africa on a lagune/lagoon serving this major port. Without wanting to live there, I loved my visits. I loved too the plane ride over the Sahara. After the well-occupied Rhone Valley and blue Mediterranean Sea, the desert's vast ongoing emptiness, the yellow-brown pock-marked camps and the few green oases are shocking. The descent started as we crossed the curving brown snake of the Niger River. Mum would have loved these views if not the ride. Live maps below me.

LIGHT ON DARK is in southwest New Mexico USA, in mountains close to Arizona and west of Silver City. We had driven down from stony Acoma, crisscrossing the Continental Divide, discovering the south flowing San Francisco River, then these trees in afternoon sun. Cottonwoods especially in such beautiful fields, against such dramatic skies, new to me, I fell for them. I hunger to see them again in Fall

color in November in these 'bottom fields'. English city-boy, I began to feel the thrill of 'settling the west', provided this beauty prevailed together with bountiful crops and grazing, which was not always so, including tragic fast-burning killer mountain-forest fires not much farther west in 2013.

LINE BOAT FLOWERS is a backwater in Inisheer, one of the three Aran Islands off the west coast of Ireland. No monuments, mass demos, no cathedrals or crime. Mass beauty in one small boat tethered for safety against a hulking rock. Monumental loveliness there is indeed. Nature's cathedrals in the skies and seas. It's a crime only to miss spaces and corners of loveliness. People leave here for gainful work and family income. People return for the gifts of light and air and peace when the winds and seas die down.

LIVING ROOM WINDOW looks out onto a local lane in an eastern village in Essex England. More of my family live here. Three thousand share a well-managed village community within a mile or so of the Saxon-medieval church and the now non-religious Priory (Henry 8 took it). Cars zoom by the window on their way to the beach community devoted to sun and sea retirement. Beside this old house is a very modern house, built by owners having the energies and talent to source Belgian dark bricks, dig 10 feet down to tap the earth's heat, install roof PV panels and super-efficient insulation while also developing a large tidy garden along a small stream. Wind turbines are turning, slowly, down the street and out at sea, producing a small percent of electricity needed. The new threaded into the old, the old holding out in comfortable activity. Local lads and lasses in their teen times still make various mischiefs much as the Bard, Mr Shakespeare, described in his time. National awards come to the village for managing public interests well (cricket club, war memorial, senior meals and events, playground equipment) and for their professional presentation of annual reports, and for a news magazine printed and online monthly.

MIRROR FALL: the great bank of trees and lake are in a suburban park in Virginia USA near Dulles Airport. I took pictures both this way up and an as-you-see-it

'normal' image. For my book I preferred this upside down view if only to help us re-view our view. Art teachers with an abundant imagination ask pupils to stand on their heads, look at the scene through smoky glass or a glass of water. For me the colors are more dramatic the 'wrong way round'. There's not much trickery in this picture. It is quickly obvious what's happened. It is pleasing in these days of overall concreting of our towns, with climate-change sweating and freezing our brows, to find such an oasis of calm and beauty.

MUD PAINTER is preparing Easter flower displays in the gardens of the President Hotel in Yamoussoukro, capital of Ivory Coast. Large panels were erected in situ and covered with this mud. Flowers were then implanted in patterns telling the Easter story. I was there for the grand party on Easter Sunday. Everyone dressed joyfully beyond their 'Sunday best'. Fellers in fancy suits, females in far fancier frocks and outrageous hats. Whether this mud painter received any Easter bonus I don't know. He deserved one for the labor and another for the successful flower-pictures staying secure through a hot rainstorm.

OLD SUNSET OAK stands somewhere in middle England. Sadly, my memory will not return to tell exactly where it is. I asked my English brother, who cares for the trees at home while his wife cares for the flowers. There is crossover responsibility, I imagine for shrubs. He says the tree looks oak-ish. Traveling through the English countryside, it is easy to see lone trees like this, some planted or left in place as self-seeded markers of boundaries of ownership since very ancient times, often in conjunction with great boulder corner-stones from before history. We see too, hedgerows of bushes and small trees, and lines of trees framing fields, many planted during the times of 'Enclosure' when landlords took common land into their ownership in various sizes and shapes that makes middle England look the way it looks. Look over Wales, Scotland and Ireland for other countrysides, especially their western edges where Celtic culture lingers longer. Find as you look, smallholdings, tiny settlements, few great buildings or towns, much country space, more wriggling roadways, hillsides, mountains, and no Roman ruins in

Ireland: they never went there. Left-brain Romans, right-brain Celts. Both at work. Differently. Few hedgerows.

PASSING PARADISE lies off the island of Moorea in French Polynesia. We rented a sail boat with the young owner-couple as crew. He sailed with casual calm and skill. She provided gastronomic delights spread on wide platters with napkins, wine glasses and 'decent' French wine (of course). A bit like the owl and the pussy-cat we half 'went to sea' but not in a 'pea-green boat'. Circumnavigated the island. No big deal, but we did. Winds and sun cooperated as the picture suggests. We, the crew and life all cooperated, naturally, happily, easily. Just that it was our last day 'out'. Sadness with joy. Paradise perhaps for part of a day. Passing Paradise for sure. Worth the trip even without getting as far as more exotic Bora Bora. This arm's-length atoll did for us. Perfectly.

RED BOW AT JONES POINT comes from a postcard made from two pictures I exhibited at Gallery West, then close by on South Union Street in Alexandria Virginia USA. Jones Point is the last piece of Old Town with this 1855 lighthouse. A 1791 stone in the river water beyond the fence here marks the southernmost point in the diamond shape of the original Washington DC. A Daughters of the American Revolution panel celebrates Margaret Brent, the 1655 owner of 700 acres, now in Alexandria city. Full of history and significance for America, the park surrounding the point is good for walks and dogs to play with owners. It feels low. It is so. It makes the Potomac look like the Mississippi.

RICE CURVES is on the road to Sapa in the northern extremities of Vietnam. From Hanoi we took a sleeping car train, two bunks either side of each compartment, modeled on the Orient Express. It followed the Red River up to the town and river bridge crossing into China. Then we climbed across railroad tracks to a good new bus to spend much of the morning crawling happily up these hills, stopping for photos (they understand the tourist system already). Cows and tiny houses fall off the edges toward these sorts of ravines. It seems that rice paddy terraces are being squeezed across all possible hill-sides. H'Mong tribal groups come to trade with

us wherever we go once we explore beyond Sapa. Colorful cloth headdresses and waist bands, silver bangles and medallions on dark long dresses mark out each tribal group. I walk their fields muddily between two helping H'Mong girls' hands. It was a spa town for the French (of late departed memory), crowded against steep hills as in Nepal and Tibet. Far higher mountains are the backdrop, shrouded in clouds and rainy mists. Looking down onto larger expanses of farmed hills, I see how the H'Mong people shape their low roofed homes into flatter plots whatever the surrounding steepness here at the eastern limits of the Himalaya.

RIVER BRANCH, one tree against the River Potomac south of Alexandria Virginia USA sits lightly, asking (I thought) to be photographed. Near Belle Haven on the Mount Vernon Trail this is a favorite walking trail for us and for many, even battling battalions of bikers. It is level. The water is close at every point. Trees add to the view, standing and fallen. It has a forested feel as well as a manicured look at the National Park Service sites.

ROADSIDE FLOWERS are on sale in the grounds of the President Hotel in Yamoussoukro capital of Ivory Coast. Every weekend a regular market springs up for cultural artifacts, local T-shirts and an imaginative collection of flora. More than a 'bunch' of flowers, this makes an extraordinary display. Some vendors wear attention-grabbing T-shirts, even parading the attractions of London, an example I saw no need to buy. This hotel gave both locals and visitors a garden-like setting in which I found beautiful flowering plants as well as flowers like these for sale on empty parking spaces.

ROCK BALL sits atop this barren hill, named the Burren, on the west coast of Ireland. To the north is Galway Bay and we see here the water-way to America, the Atlantic Ocean. Look beyond the ball and down on the coast with a tiny port and the ferry to Inisheer is Doolin, where each pub makes its own versions of Irish music, each claiming to be chief in the music business and one of Ireland's capitals of fiddling and singing merrily and nightly. The little working-boat ferry to

Inisheer, toughened to deal with the rougher winds and waters that come with little warning, took us into the heart of the islands' Irishness.

ROCKS AND WAVES is a far point along Maine's coastline, near Camden and its busy-pretty port. There is sailing history to report, but mostly it's the water and landscape setting: its location, location, location. Wandering these Maine coasts is a constant joy, diving away off Route 1's traffic, down small lanes into the edges of the ocean, we find quiet as well as the noise of the waves. Sea-girt is the word, home for sea-creatures, them and us, water lovers all. We started here, much as on Long Island's 'Dividing Point' (back a few pages).

ROW BOATS are waiting for hire at Bowness on Windermere at the southern edge of the English Lake District, nearly 300 miles northwest of London. A short local train line connects London's expresses with this lake (I should call it a 'mere', as in its name) giving us access to the mountainous country all around. A red Ribble single deck bus then carried us into the heart of heaven to Elterwater at the entry to Langdale. I learned to sail on this 'mere' in a 6 foot pram dinghy taught by John, a good school friend from Liverpool. The winds off the hills blew every-which-way! I walked as a teen one week a year, with Scout groups at Easter break through rain and shine, up to the tops at 2,000 to 3,000 feet, using detailed contour-colored Ordnance Survey maps to get us out of trouble in heavy cloud-mists, with jagged crags below. We lived in stone cabins beside the small cold, cold torrent in which we swam. These times of young walking-climbing nature-lovers live on deep inside me. We youngsters never used the row boats but seeing them brings larger memories including the narrow memory of the shock of entering that cold, cold stream.

SCHOOLBOYS make faces in a small park in the center of Abidjan Ivory Coast. Lunchtime out of office meetings a block away let me wander with my camera. The boys seem naturally boisterous and friendly towards my interest in them and their smiles. I take several pictures that remind me of happy unplanned encounters in an African city. A minute later I see an older building below me and take more pictures leading to an unhappy unplanned encounter. This building, with

interesting architecture that I am always interested to explore, turns out to be a military headquarters. One uniformed man runs fast across the busy street directly at me, shouting in a French I do not understand. He grabs my camera and runs back inside the military gates. Wanting at least to get my camera back, I have the temerity to cross after the guy, find a door that let me in up some stairs. In my best English schoolboy-inflected French I make a small scene asking to see an officer. I am forced to return the next day, with a meeting, an apology from me, and thankfully the return of my camera, less the used film. My moral is to be far more observant (look-see more) when photographing anywhere near official property however interesting their architecture. A second is to persevere in pursuit of my interests, in this case to regain my means for gathering more photos. And 'toujours la politesse'. Once long before in Beirut, a local man objected to my photographing an untidy pile of vegetables in a street market. In the same schoolboy French, I was able to explain that the beautiful colors and settings were what I wanted to convey to my friends. Amazingly, the man immediately accepted that rationale, steeped as he had to have been in some cultural appreciation of the artistic sense of 'beauty'. All praise to art!

SCREES AND GREENS shows us more mountain drama, north of Hanmer on South Island New Zealand. In a well-used original Land Rover we had ground our gears and tires ever higher and over ever more stony tracks to pause to look up and further. Beyond having the energy to climb these, I only marvel at their shape and size, at their colors, textures and challenges. These 'Southern Alps' were named by arriving British settlers in the nineteenth century, in the spirit of Whymper on the Matterhorn and Mallory on Everest. They stand in my face calling. Looking here at 7,000 feet in the northern ends of the unbroken range which includes to the south the 12,000 feet Mt Cook, I feel liberated, if earth-bound, in their presence. See, not tiny islands in a vast Pacific, New Zealand is many lands of open spaces. Air is cool, fresh, good enough to bottle.

SIDE STREAM runs close by the 'Glitter Glass' shop below the heights of the Cathedral and Castle overlooking the end of the Charles Bridge on the left bank

125

of the Vltava in Prague Czech Republic. I suppose we could paddle down here but in walking mode, we stand and look. Walking is the one way to find beauty, unexpected, around in city, country, gallery, crowds, above in skies and trees and minds. Praha has parks, streets and buildings being tidied, replastered, repainted. A hundred yards behind this picture is the easy tree-filled grassy walk beside the main river feeding this side stream, a watery side street, carrying me into more local encounters, people, dogs, birds, leaves.

SILVER AND PURPLE is a microcosm of Saigon or Ho Chi Minh City Vietnam. Lines and patterns, open and hidden, dull and bright, color and darkness all are a part of what we found in Vietnam. I wake to a misty early hot sun-light that fogs my camera. I thread my way across the wide already traffic-busy street, finding this park of walkers, small pet dogs, Tai Chi men, chatting women friends, chess players, smokers, more older people than younger, and a lengthy narrow lake home to these lilies. Comfortable with colors of many hues and strengths, from Vietnam Airline uniforms to dress shop decor and basic street bunting, an eyeful of delights is ready for me in all directions. One distraction is the web of overhead lines carrying telephone signals to the world, looking (I don't know) at a thousand lines for every country you can name, certainly crowds of cats' cradles around each post, across to every building, in and out of every office and apartment, a poor version of the delicate stems of these lilies, as wildly wacky as the lilies' shimmering beauty, catching my eye for better or worse and holding it. I move back through much heavier traffic for a day of more of everything I mentioned. We go with the flow.

SNOWBOUND FASTNESS gives me an in-my-face look in early Fall at the summit of Mount Rainier, Washington State USA. We parked at the snow line, walked a little onto it, stopped before we got into trouble, and looked. This monster of a mountain stared back like this once we moved further away. Healthy and horrendous, it is difficult to take in though worth the effort riding in a circle fully around the beast, and its beauty. Rainier keeps an eye on us too from downtown Seattle, looming from a long drive distant.

SOLDIER GARDENER is a guy working in a market garden 'allotment' beside my daily walk from the Hotel Golfe on the outskirts of Abidjan Ivory Coast. I quietly poke my nose into everything I notice especially when different from my regular experiences in USA. Clearly some working in the rough grounds seen behind this man were serving the needs of restaurants in town. This man seems more an individualist and it is unclear where he has his 'job', which plot he works. His attitude and stance speak of a trained disciplined approach that I never fathomed, but I believe it shows in my image. A 'good guy' I thought who would respond to requests to cooperate if asked. I live in hopeful assumptions! More prosaically he could stop someone attacking me, or pick me up after an attack. Working watering can and machete as lines of defense.

SOUTH SEAS is our water level view of Moorea in French Polynesia. Flying into Papeete, a Gallic busy-ness of a Pacific Island city, we took a communal launch to carry us speedily breezily to our relaxing waterside accommodations on Moorea. Going fully round the island the next day in a small and simple sail boat, we found ourselves happily afloat in South Seas nirvana. Try it one day. A sailing without frills but with friendly locals bearing food and fruits and wines, we lay back in our own version of life's luxury of color, crests and clouds. Truly magnifique!

STAVES BRIGHT LIGHTS mark the entry of Hunting Creek into the Potomac River and the dividing line between Alexandria City Virginia and Fairfax County Virginia USA. The sand bank increases and decreases with a three feet tidal rise and fall, creating different versions of the crescent. Low levels of river offer feeding chances to bald eagles, nesting locally, to sea eagles or ospreys as you prefer, to thousands of geese, migrating raptors, duck and hosts of other birds following America's eastern seaboard flyways. The stone bridge is on the Mount Vernon Parkway, and a happy fishing spot thanks to the efforts of the 1930s Civilian Conservation Corps who built the elegant curves of the road, a commuter drivers' joy, a walking-biking trail winding neatly alongside.

SUSSEX FLY SAXON CHURCH is on a porch roof tile, with visitor, in ancient tiny Friston, high on the South Downs (down being an early version of dune) above East Dean, Sussex England. Whenever I can get there, I walk from this church directly on the turf towards the sea winds of the English Channel, La Manche, 'the sleeve' to our French relations, a medieval woman's long sleeve narrow at the top, flowing broadly at the cuff, like the Channel narrow at Dover, broad opposite Cherbourg and Brittany. It is home to my parents' remains. My favorite aunt Vida, my mother's sister, once owned an old flint-built bake-house in East Dean opposite the pub on its green. Friston has a farm, a dew pond, and this thousand year old church, and heart-stopping views towards the top of the white cliffs of the Seven Sisters and Beachy Head where the lighthouse sits on the flint-stone-filled beach below 300 feet chalk cliffs. The battle of Hastings and the white cliffs of Dover are some miles east. I learned here to love stories of the past, the ground and our constructs, especially of what we can see.

TREE BARK GRAY takes us towards my tree-hugging inclinations. I rarely actually hug them but they cry out to be hugged as I look at them. I have circled a tree to gauge its girth with my outstretched arms before it was killed off and dismantled, having become too large and dangerous to people driving by. Park Authorities have such powers of life and death. I have on one bookshelf a two-feet long piece of a felled chestnut-oak rescued for me at my request by the fellers (executioners have hearts too). I had to take a leaf of this quercus castana to the Headquarters of the American Horticultural Society for identification. Scalloped oak-y edges and chestnut-y oval shape were new to me. For contrast this lovely gray bark was a first I chose to photograph, then to present laid down horizontally, from my walking the Mount Vernon Trail beside the Potomac in Alexandria Virginia. I am fascinated by the endless variety of bark textures and the colorings and the coverings of ivy and lichen and growths afflicting small and great trees. Openings and hollows worn at the edges add still more character to each tree I stop at. My poor family sometimes waits for me and sometimes they walk on faster than I at the best of my paces. I want to look harder, to remember these character trees. I am a maddening slow-coach of a walker anywhere, for the tree views and for the long distance

views, the panoramas, with trees, allees. I talk as I drive to 5 year olds of 'grandes vues', a phrase I borrowed from the inscription under an etching of a Loire chateau we once visited working our way through France. Tree silhouettes, on hillsides, against water and color-filled skies thrill me as much as anything in nature. 'Quite mad' some say, all for the sake of 'beauty'!

TREE BARK JADE another in this tree series, is also on the Mount Vernon Trail, Alexandria Virginia USA. Chosen to demonstrate the variety found a short way from 'Tree Bark Gray'. I understand the predilection of ancient people such as the Celts to be respectful when standing in a grove of trees. We stand, trees stand. Trees have trunks, arms and crowns. Both we and trees live uncertain numbers of years and face uncertain amounts and types of sickness. We are both survivors, and both one of nature's species much affecting other species' lives. 'Green Men', creatures of the forests, were carved into house corners and decorations in churches to represent some mutual care for 'people' and 'things' living well together. Trees matter to me so in return I praise them here.

TREES AT SEA stand (of course!) by the Pacific Ocean on the strand at Takapuna, over the bridge north of Auckland New Zealand. They are grand examples of the Pohutukawa trees that shower our eyes in spring and summer, over Christmas down-under, with huge displays of spikey trumpets of scarlet flowers. Their branches spread a welcome to epiphites in profusion. They add much to nature's glories in ways unexpected by we Europeans arriving late in the nineteenth century. They are huge and overwhelming in a warm South Pacific way. Along the beach is a small house whose garden runs directly into the sands. A low wall separates the green from the golden, a totally pleasing setting I wanted, not very realistically, to buy. We know many forms and fashions of Pacific beauty, some intermingled with Englishness in gardens, others quite different and uniquely 'Kiwi'. Underlining this point are the stories of dissension between lovers of cats and birds. Cats being predatory imports, attack native birds which have had no experience of killer mammals. The ground-living flightless Kiwi birds emphasize the point, as do the kea parrots landing fearlessly on my car as soon as we stop.

Clearing small southern Stewart Island of invasive pestilential species affects but 400 people out of four million in the nation. We assume the 40 million NZ sheep, invader mammals too, are welcome. We assume that rats are not! So sheep are 'friends'? Kids have pet rats. Watch this space.

TWO TREE CHAIR is a quiet spot outside Bar Harbor Maine USA. We had worked our way up the coast from Portland through Camden to the Acadia National Park. Sights are of shingle and stone and rock in massive formations interspersed with tree and shore. Here is one calm waterside resting place thanks to caring B&B owners willing to tame the natural wildness enough to position one easy chair between two trees. Birch tree with its peeling bark is worth including in this story, and a reminder we are north cool not south hot. Nevertheless we can linger here in sufficiently warm clothing, looking-seeing.

UNDERCROFT ARCHES live below the ruins of Fountains Abbey in north Yorkshire England. It is one of the loveliest properties appropriated by Henry 7 in separating himself from the Papal Roman Church controls which irked his rebellious Welsh spirit. Sheep live well in the north of England as the Romans discovered, first for meat, then for wool's warmth, to the relief of shivering soldiers up from sunnier Italy, France and Spain. A thousand years later the same properties fuel the money supply beyond abbots to today's land-hungry 'squires'. The king took his portion while gifting these arches below and above, receiving in return strong lay loyalty and the beginning of the reciprocal friendships between kings and mid-level English landowners. Other northern abbey ruins, once wealthy with wool profits, still astonish me with their architectural magnificence. Even in fragments, covered in lawns where cloisters were, related quiet and peace reign, holy and otherwise. On the hills and moors sheep still graze, old stone barns are networked into walls that run straight up and over the dales' steep sides. All are still labors of love and money. Costs are high in time and attention to rules, when farming or living where the National Park and the National Trust govern changes. They work to preserve an ancient scenery where 'barn-conversions' are 'des res'

items, so pushing up prices for 'desirable-residences' even with limited permits to 'modernize'.

WALKING STONES are known as Tarr Steps near Postbridge, Devon England, and have been helping people across this rushing stream, the East Dart on the side of Dartmoor from a 'time-before-time'. Archeologist research says that they were first set here over 2000 years ago. Certainly traders were moving flints, tin, bronze out into Europe, and lapis lazuli and glass from Europe along well known long distance trails from the time of the circles of Stonehenge, started about 5000 years BCE. Excavations in Amesbury, near Stonehenge, now suggest an even more ancient story, to 7000 years BCE. Excessive rains in 2012/2013 moved some stones off their supports. This shocked me, thinking nothing had ever shifted such stalwart stones of history. Yet at Stonehenge and Avebury far larger stones have fallen in the untended years they have been in place. This bridge connects with track-ways to many stone circles in the British Islands and others across Europe. Looking-seeing-walking.

WALL DÉCOR towel and fruit dress a wall in the suburbs of Yamoussoukro Ivory Coast. I walked past these walled compounds daily, some as smartly kept, others unkempt. The very orderly way the towel is spread makes me wonder if the owners are military. I rarely saw people at the gates and never heard noises from inside. In the original village I can only imagine noises of people and beasts all the time. These are houses of outsiders come to run the offices of government newly established in this new capital city. We are 200 miles both from the busyness of Abidjan and the noises of Africa. Here it is strangely calm. Away from these houses towards the city center in the street are men's hair cutters, electrical outfitters, news-vendors, dress makers, laundry people, all working out of the simplest wooden shelters scattered in no set pattern. The more enterprising baker had a padlocked store of corrugated-iron behind his shop and oven shed.

WATER LIGHTS was taken soon after the 1996 snow storms, looking into Hog Gut from the Mount Vernon Trail's wooden bridge near Belle Haven, Alexandria

Virginia USA. The patterns on the water with the odd collection of flotsam caught my eye. Abstract and curious images inviting a variety of explanation appeal to my interest in imagination and its workings. Exchanges over discerning this or that image in an abstract, when none is a given, always to me bring excitements of discovery and satisfactions of sharing new visions. It is a variation on walking a gallery with an artist friend, looking and seeing different aspects of the work. Challenge and result in the same time frame can't be bad. I hang this in my bathroom.

WHITE ON GREEN is a near-abstract, two colors contrasting, inside the walls of King Richard III's castle at Middleham, Yorkshire England. Richard was the loser in the 'Wars of the Roses', the Red rose of the Lancastrians and the White of the Yorkshire crowd. He it was in Shakespeare's words who cried 'My kingdom for a horse', which he didn't get, dying on the Bosworth battle-field. So what do I make amusingly of this horse, in his family white, the horse he wanted perhaps, but late for the fight. Richard's bones were uncovered in 2012 below a municipal car park in Leicester, a hundred miles south of here and a hundred north of London. The fight recently has been over where his last resting place would be. York lost again and the hunchback's tomb will stay in Leicester.

WINDOW BLIND lets this gentle light into a home 20 miles north of London England. As this is south-facing, the sun can be strong enough to need a blind although here in early winter the blind's colors are giving us the warmth. These owners are a modern family with an appreciation of design both antique and modern, and a garden the width of the house, not open to the public. My brother raises money for their village Elizabethan church tower by opening their garden occasionally, publicized through a reference guide-book, 'The Yellow Book'. Let's pull up the blind to see the garden, please!

WINDOW WALL catches sun in early winter on hard-baked adobe in Taos, New Mexico USA. Many Taos houses have very little light through windows like this, small and few. It's a practical solution given the heat and strength of summer sunlight and the deep colds of winter. We walked between the houses and wandered

the shallow stream edges facing this house. It is one of dozens built atop each other, with simple wooden ladders propped against the wall. Must they paint the strong colors often?

AFTER-WORDS

Other Lives

I have shadow stories to tell that illuminate the shadows.

Balancing the joys of companionly travel with eyes open and camera in hand, are painful and sharpening observations of life arrived through my divorces and separations, from my English wife, from my New Zealand wife, and from a good, close and long-time friend. Other friendships I left behind enlivened all the times between. All are married again. 'Happily ever after' possibly: I hope so, but it's not for me to say.

There was more good than bad; the good was always very good. Quite unlike my parents and my brother, I moved, often. The black sheep. At this long remove, I say 'baa', hello to everyone.

I was told how immature I was, in marriage, in parenting. Blind then, I imagine I now can see. Assumptions, like this, carry dangers and call for caution. But to look-see-listen openly requires a mostly worry-free approach based on a confident 'I can'. Some worry takes the edge off over-confidence. Too much kills it all.

It also needs a risk-taking approach, risks of not knowing what I'll come to. I often calculated my risks rather than theirs. Deep 'looking-seeing-listening'

matters, matters massively. Add 'tasting' to the calculus, a trying-before-taking. So, l-s-l-t is my mnemonic, in quiet lower case not screaming capitals. Some toe in water first.

Here are some positive personal contexts.

I met my first wife, Kit, from England on the stage: she played Alice, I the Mad Hatter (type-casting). We speed-cruised in Minis (before Cooper invented Coopers) between London and Geneva, down narrow French highways, perilously lined with mesmerizingly spaced trees, wound our way high to Italy's Lago di Orta. We both welcomed, exceedingly, our daughter Pippa. With her in the bassinet across the Mini's back seat, we sped the new Motorways north-west into the Lake District and east by older (winding, sick-inducing) cross-country byways to brother Mark in Essex with his wife Rosemary and their three-daughter brood.

With Pippa and a cousin in an Austin Maxi five-door hatchback (early version of that breed) we explored Brittany, then the length of the Côte d'Atlantique (on platters of sea-food), moving west from Biarritz and San Sebastian (by way of the prehistoric cave paintings of Altamira), stayed in Zarauz (joining a wedding by young Pippa befriending the bride) as far as Santiago de Compostela (without once footing the Pilgims Way), wore pink on sandy beaches in Bayona (where a toe was painfully pierced), took a brief look at Portugal's big breezy shores.

My second wife Pamela from New Zealand was on my first week's Coverdale work in USA. Pippa and I traveled the eastern seaboard from Delaware's beaches to North Carolina's Outer Banks by way of America's historic places (I am a historian, after all). We 'did' Washington's Smithsonian, delighting in Smithson's story, Scot, Enlightenment man, moneyed through his Mother, never once coming across the 'pond', believing in the Founding Fathers' approach to running a New World nation. For applying his wealth to a good new cause, Washington seemed a good exchange for London.

Pam and I circled the world visiting her NZ and Aussie families from Christchurch to Perth. We rode trains across America and Australia, up and down New Zealand. We cruised the Marlborough Sounds and went south through Christchurch to Dunedin (Edinburgh, re-cast), and Queenstown to cruise past the

near 5000 ft Mitre Peak. We drove the shorelines from Nelson to the retreating Fox Glacier. We stayed on Waiheke Island before it became the darling of wine-lovers and out of town Aucklanders. I was welcomed wherever we went, brute Pommie that I was, wearing Kiwi 'walk-shorts' to prove I could (I'm sure not very well).

My interest in the travel business started as a guide in Germany and Italy as a college kid working for the London Youth Travel Bureau. I spoke good German on the Rhine valley, discovering the joys of VW mini-buses riding in them high above the river and vineyard hill-sides. I botched Italian with my Spanish-inflected Anglo in Verona (La Scala opera was performing in the Roman Arena) and Venice (private group gondolas for the fireworks off San Marco). I driver-guided Italians to Ireland's subtropical southwest. My 20-year-long travel professional friendship with Judy took off with my driver-guiding her and her friend in London. I guided clients of hers in England. In USA she met me at her airport with a loaded picnic basket.

We started organizing tours to raise funds for a community orchestra near home in Alexandria. We took Orchestra Friends to Prague (private concerts with a Sony recording violinist in an ancient family chapel) and Budapest (ceramic-buying side trips up-river to Szentendre, Hungarian Saint Andrews) as both cities became popular. We helped people through Rome, Assisi, Siena, San Gimignano, Lucca, Florence, Verona and Venice again. I photographed like I was possessed. I was! Everything opened my eyes. I was welcomed everywhere, 'taken into family'. I was given personally selected visits and music events. Went to parts of Europe I didn't know. Exploring, looking-seeing-listening-tasting to the full. Beautiful.

From Edinburgh Scotland Pippa and I flew in a small tartan-decorated plane to the Outer Hebrides. On Lewis we found my nirvana of ancient standing stones: Callanish. Skinny, sharp, as old as Stonehenge, exposed to the elements on Lewis' furthest extremities. USA next stop! We reveled in the windy bright sweeping beaches of Harris, shimmering white in bays along the south-west shores. Eye-watering. Drama and remoteness, sadness in Scottish histories of eviction and migration.

Later in life I realized how my parents brought me up in a world of Authority. Dad, quiet, mild-mannered, thorough in everything, was not only Dad. He was a respected member of the teaching staff in my school, many of whom were regular visitors in our house. He was my math teacher (until he decided to give the job up after I made an embarrassing 4% in one test). He was my school troop's Scout Master. In our church he was Treasurer (we counted heavy half-crowns together), and with Mum were both deeply loved members of each community.

They had me surrounded. Doubting myself was second nature. Being tongue-tied with them was normal. Naturally I over-compensated with my own form of bragadocio. That blinded, deafened me even to common sense, certainly to others' wisdom. Raise your awareness levels young man.

I came to take more mature (I think) command of my deeper life in my later years. My life of watching for 'Authority' may have raised my awareness for look-ing-seeing. After and with everything, here I still am!

It was at a workshop aged 50 plus, marking adjectives from a given list, that I suddenly realized I could not mark 'fun' as a word describing my early life. We enjoyed much that we did, seriously, separately and together. Light-hearted laugh-ter and 'Fun' though, it wasn't. My rare giggles in public embarrassed me.

I was as tongue-tied in front of girls. Imagination I had in bundles. Reality was another matter. And I wanted what I wanted. Whose I? I stole slight moments as they arrived. Describe the indescribable to others, let alone to myself? Ha! Stand my ground? Tell it truly like it is? Impossible. Only once was I absolutely con-vinced I'd found the one. Once met, known for ever. Fifty years ago.

Then I played safe, by the rules I'd been given. I stayed with the known. I didn't grasp the nettle of the new. For all the good I since experienced, more's the pity. Breeding ground for uncertainties. Building houses on sand.

'Blast', as Dad would say. It was his one imprecation. With 'blithering idiot', marking homework.

I went on to grasp loads of new nettles. But never the one.

My New Yorker US Environmental Protection Agency child health specialist and very 'tree-hugger' wife Kathy now travels the trail with me since 2002. Once noticed across our crowded church, we connected, first for a month by long-range email, then eye to eye and tooth to tooth (whatever). Close quarters anyway. Still connected like this. A dozen years and counting.

Our big experiences have been with our adopted family to Vietnam. We traveled with the Vietnamese who organized our adoptions, and knew the way to meeting locals. One insider took us into their family estate outside Hanoi, filled with beautiful art and craft in their ancient home. Starting in Saigon/Ho Chi Minh City we visited a school for blind musical youngsters, taking them saxes, guitars, flutes, donated in USA. We saw a clinic opened for abandoned babies that we had helped fund. We drove deep into the country to visit a business-minded mother in their simple home with a thoughtful husband, active children, a brood of laying hens (income), as she took delivery of a cow (more income).

We flew Vietnam Air in new Airbuses with smart newly minted cabin crew. We worked our way north, through old conflict zones that are no longer any conflict, much more new business opportunities (Heineken is everywhere). China Beach, Marble Mountain, Hoi An (made to measure silk dresses and an embroidered vest). Hanoi old town, the 1000 year old university in its walled compound, the Metropole Hotel (Graham Greene cocktail at the poolside bar, a vintage Citroen sedan out front). Walking across the streaming traffic without signals or police needed nerve and knowing the trick of weaving slowly but determinedly in one clear direction, allowing drivers to pinpoint you and to pass you safely, keeping their speed.

We took the train to the Chinese border, a bus into the hills and the world of H'Mong minorities, their tightly settled hill villages under enormous thatched roofs. One peaceful junk-hotel (more a private B&B) for an overnight in Ha Long Bay. We gave gifts to the woman, sitting in her coracle, leader of floating village

people needing floating schools and better allocations of government support. We became engaged in caring help at work. With old and young, smiles count!

Kathy is a committed warm water scuba diver. Kevin learned in a chilly Virginia flooded pit. The doctors don't allow me, cold or warm, and my swimming isn't up to the job. So I watch, snorkeling when I can, tutored by dark Belizean guys in wet suits. We have a date to be in St Lucia to celebrate Kathy's retirement in August. Anse Chastanet, one of those 'places to see before you die'. Eye-opening in comfort (Pitons ahead, scuba from the beach). I read, I know how to chat up the locals, sample the fare at table particularly any fresh fish, try a local beer. Write my writing. Stay out of the sun (shade of tree, balcony, hat). Snooze. Watch birds both girls and feathered. Shuffle round ruins (sugar mills here, possibly I will). Read. Write. Repeat.

Kathy has also been opened to British everything. To Yorkshire Dales and moors, to Skye-scapes and sea lochs in Scotland, to hiking the rolling Downs of Sussex, to skittle alleys in Dorset, to cathedrals in York and Wells, to full English breakfasts in B&Bs, to fish and chips in paper bags, to an Elizabethan castle in Norfolk in snowy cold, to my family and friends. I'm doing my best to balance the culture shocks. But I won't over-balance.

I am a northern Englishman more accustomed to winds and weathers. Obtusely, I like being warmly bundled up, a blazing fire ahead. I am more older than younger, so feel likely to stay closer to warm than cold. I'll also take air-conditioning to cool me in summer heat. Waters with hills are my 'thing'. So are small communities close to learning and beauty, colleges and churches, books and music close by. Bangers and mash, fresh caught plaice, tapas! Nose me into a Loire or Kiwi Sauvignon Blanc, an Alsace Gewürtztraminer, Bordeaux Pomerol and Paulliac, Rioja Marquès de Riscal, Oporto port, Southeast (or west) Aussie chardonnay, cold cold Veuve Cliquot champagne, Ontario ice wine, Finlandia vodka, any Speyside single malt. European pubs/bars, 'norteamericano' BBQs.

Where did all that come from? Mum got squiffy on a smell of sherry. Dad's ceremonial bottle of Christmas sherry lasted a few years. Somerset cider came out in careful measures on summer days (a potent liquid). We never knew our

grandmothers, long deceased. Neither grandfather showed any love for drinking: Dad's Dad was a devout member of the ascetic 'Plymouth Brethren' (not even Sunday games on the beach) although four wives predeceased him. Mum's Dad's only vices were a smelly pipe, a stubby moustache and prickly kisses.

Most certainly my interest started in Emmanuel and sustained through work and friends. I hate a drink alone.

In Debt

I am in debt to all who trailed the trails with me and who still keep my eyes opening.

I am also in much debt to those I left in the lurch. There was much we loved together, but I left. I did not repay the good given me in many families who took me in with openness and with mountains of tender loving care and led me to many good times and friends. Old and young, near and far, I left much behind.

I behaved spectacularly unlike my parents. Quite why is no mystery: I looked and saw only what I wanted to see and stopped listening. Wilfully ignoring the facts tells me to keep looking and that listening-tasting is as important. Dogged determination gets you into dog-houses (where else?) That sort of misbehavior colors everything since. My inner colors, however, are bright. I have 'moved on' as counselors say. That I move on with, not 'gay abandon', but an inner depth and stability reassures me. I keep moving, I am a journey-man.

Pippa also gives me good times whenever we visit or talk. My brother, friends, some from early work, from school days, even back to baby days in Yorkshire, all give me good times. Pippa is the heart of my best.

After our Yorkshire origins, Essex has become a second family-place. Allison first, Katie second and Nicky third are my nieces and Pippa's cousins. They are close family, now with their own offspring. They visit here as they get free. Their families extend to Australia and New Zealand where we have all visited. I have my own extended family in America. All are 'best' for me.

My deepest shadow story is of the young woman who crossed the aisles at the Food Show in Hampstead Town Hall in the first year of my first marriage. She said to me "I had to come over to find out whose voice this is". We led a chaste but passionate friendship for a year. Here was my 'nettle of the new'.

We connected on many levels including my meeting her mother. I walked away to stay with my marriage, which ended fifteen years later. Pippa would have been a different Pippa. I would have become a different Ian. We have had no contact in 50 years. I still, with all the good life I lead, hold strong emotions about her. I'd dearly like to know she's in a good place.

My better shadow stories lead to knowing my higher power lives in my desire to take pictures and write. Here is where I come to life. I am passionate about the best of my photographs. I love the light out there. I love playing with words, words of mine, of friends, of far cleverer writers. I read dictionaries for fun (fun!). I love people and places they love. I love my own places, actual and remembered, open and silent.

Quotations

I have some 'looking-seeing-listening-tasting' quotations to journey with me:

Marcel Proust said 'The real voyage of discovery consists not in seeking new landscapes, but in having new eyes' … French author of 'A la recherche du temps perdu' … 1871 to 1922.

Richard Rohr says 'I love what I see: life excites me' … 'The Naked Now - Learning to See as the Mystics See' © 2009 by Richard Rohr … ISBN-10: 0-8245-2543-4

Solomon in the Book of Ecclesiastes in the Bible of the Hebrews and the Christians says 'No man can say his eyes have had enough of seeing, his ears their fill of hearing'.

Ralph Coverdale said 'there is no learning without contrast' ('variety the spice of life') … looking-learning … 'Ralph Coverdale - Risk Thinking' © 1977 The Coverdale Organisation Limited …

William Blake wrote 'To see a world in a grain of sand, a heaven in a wild flower' … English poet, engraver of imaginations, together with his artist wife Catherine Boucher … 1757-1827

Some Conclusions. We need change to see change. How otherwise will we know it? How will we know where we are on our journeys without seeing change. We make the change; we allow change; we accept change that is happening. We are not always 'in charge'.

We need light to see darkness. We need silence to know noise. We need bad to see good. These are existential conundrums (or conundra if you are into Latin). We live with them daily.

I 'take pictures' that move me beyond these conundra. I wander my world looking for Beauty and the Unknowable, the differences that will put me in a sphere of life outside 'the daily grind'. 'Outsider life'.

Our 'daily grind' and our finding 'beauty' may be found together if you're very perceptive. They may be experienced in partnership if you keep looking-seeing-listening-tasting. Be buoyed by fortune and fortitude.

Through special strengths and friendships, we also recognize the 'Unknowable' even as it remains beyond knowing. I was moved deeply reading 'The Outsider' and meeting Angela in the Food Court in 1962.

I have choices. I choose to live close to beauty and the unknowable, more and more as my years increase.

Conundra (many Conundrums). One concluding conundrum has to do with what we do not see. I miss things I know I'd be glad to have seen. This does not 'faze' me any more than other items in my life. More often than not, I let it be. My 'sights' are satisfyingly full now. More will fill me more!

I accept that 'all', like 'perfection' and 'the best' are not always possible, and are almost always debatable … although maybe not always. I allow the possibility that what I missed I may later find. I allow that other different sightings will come my way and be satisfying. I will not speculate their quality, no comparisons!

'Comparisons are odious and ill-taken', Cervantes in Don Quixote. 'Comparisons are odorous', William Shakespeare in 'Much ado about Nothing'. 'Comparisons are odious, because they are impertinent' William Hazlitt. Also John Lydgate, Francesco Berni, John Fortescue, Robert Burton. Go to 'Quotations'. Enough?

I just need to be looking … at least for beautiful images … and listening for sounds to lift my heart.

My purpose is not to promote my all, my best, what reaches the gut in my 'heart-strings' (I don't pursue 'perfection') to be yours let alone the world's. In what I have here, please find some of what you enjoy. My purpose has been to share some of life's beauty that I have found and to think about it with you.

Thank you for taking me in.

I may never know if you did!

THANKS

I enjoyed this ride - except my shouting times when I kept losing my work and not knowing how my computer did things, nor what I could do. Thanks be to HELPERS everywhere.

I am a member of a weekly writing group, 'Tuesdays at Two'. We are friends and co-conspirators in the lonely art of creating from nothing, verse and prose, making words and images come to life for others. We have published three books. The encouragement and practical support from TatT members is the groundswell that started me and holds me up today. Tony Bates and Ed Simmons, with an English Coverdale friend and guest member of TatT, Sally Perkins, have deeply proofed my writings. They give critical hands-on assistance especially when my computer-electronic talents come up short.

Tony and I meet regularly to finalize his monthly blog stories. Ed, Tony and I are in a friendly 'Critical Group' that meets to listen to our writings. We work over ways to do differently what we just read. We discover deeper meanings and clarify unclarities. We read and critique other writings. We laugh and learn, liking the time together. With their healthy help, I have overcome glitches I alone have endless trouble clearing away and that easily drive me crazy. Tech and emotional salve.

Jean Noon is the fourth member with Tony and Ed of our 'critical group' of writers. Jean offered me her words for my work; 'Contemplative Seeing'. Jean is a thinker-writer with deep spirit. Her words appeal to me. CONTEMPLATIVE SEEING captures the essence of what I am doing, in both images and words: thank you.

My step-daughter Kristy Politte, a Virginia Tech Biology grad and nurse, is quick and tolerant enough with me to solve passing problems when I am in crisis mode and she is available. You may imagine there are pauses in my work when I am 'stuck' until help arrives. I am abysmally defective in what I call 'tech' matters. I catch on with her explanations, but only sometimes. I have to walk away for an hour or more to focus on what I can do. (I can write, look, listen.) Kristy is, critically, my go-to for dealing with the complexities of moving my work into production with my publishers. I 'thank goodness' and I thank Kristy.

I thank too my wife Kathy, busy in the run-up to retirement from her years of well-respected children's health work in the US Environmental Protection Agency, for putting up with my interminable silent presence in the corner chair where I write on my laptop. I look forward to lighter moments as she sees her life discovering more time and new interests we will share.

Finally I thank you who find this book worth reading. I know my language is English with American spellings. England, please allow me to pay homage to where I live in my later years.

Thank you for tolerating my idiosyncratic punctuation, in part from a desire to involve you in choosing how the sentences should run and roll inside your head. Listen for their sounding.

AFTER-THOUGHTS

I married my Mother. Kathy and Mum share tallness, boniness, sparseness. Mum did and Kathy does use a sharp mind rapidly over many topics, shared to benefit wide ranging fields of interests.

My excitement at 'and-and' masked my difficulties at saying 'no-no'. My lives under authority led me to avoid open sharing and acceptance of rules larger than I saw myself. Nevertheless, my choices.

My love of people and new experiences carry me energetically through 'thick and thin', many lives, many characteristics. Frequently I receive better than I give, but I try. I live in present and past lives, English and American, done and growing. I am a stretched historian. In a young-old together-life.

The unplanned intuitive choices of title words for each picture seem a great blessing. First I plucked good usable images (looking-seeing) from piles of pictures. Then these words came to me. Image-with-title gave it a place in the book. Right-brain led, left-brain confirmed. 'Well-fitted', not 'perfect'.

I enjoyed the ride, yes, except when I 'lost it' not knowing where my work had 'disappeared' to. It was in here, hidden in plain sight. There are various ways to look-see-listen-taste. Don't I know!

Authors need to beware making declarative 'I've finished' statements before they have. My dateline below was changed several times. Love for one's own literary baby goes beyond good sense.

What I have told is my attempt to explain sources of my interest in the seen and unseen, the apparent and the hidden. My stories tell briefly some of the origins, the opening moments of my eye-opening interests.

The images are a bonus blessing, happy outcomes of looking and seeing, camera in hand.

Images absent may be created from your knowledge, be developed in imagination, spur research.

Contemplative Seeing. Seeing with thinking. Thinking before and after looking. Sensing-seeing.

I certainly do not 'get' everything, not even everything in view. The haul here is but the haul here!

Keep an eye open, look-see high and low, near and far, large and little. Write poetry to your images.

List what's hidden! A percent hidden. You know what they are, probably where they're hiding.

Your book, your keys.

Friendships.

Beauty out of sight, so far.

Life.

Your love.

In plain sight.

Hidden.

Explore ALL the ways to look-see-listen-taste. l s l t.

I didn't, not all. Blast (or even damn and blast).

But a lot.

See you in my next book.

IAN TEMPLE ROBERTS
2013

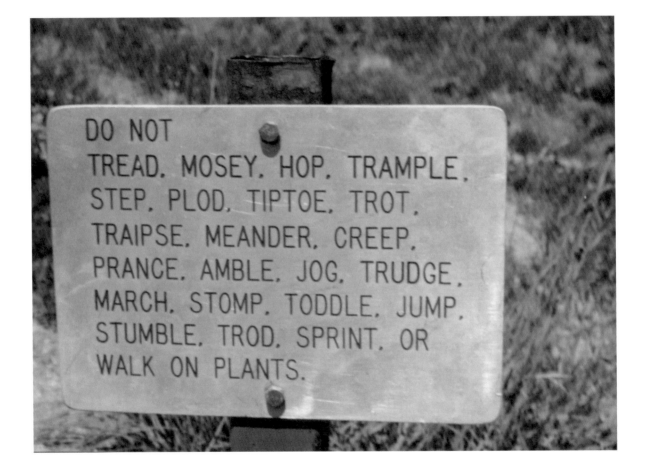

DO NOT MOSEY

What do we mean? Imagine a criminal action over each verb. Plants here have strong seriously legal-minded protectors. I had thought 'meander' only relevant to a river, from the original where Greeks battled Persians. I should be wary, meandering. This is one of those pictures lost to me. I don't have this moment in my head. I guess it refers to bluebells which carpet a few special, protected woods in England in Springtime. Some are vandalized by trophy hunters who grab handfuls of roots with the flowers. The freedom to wander our wildernesses is a gift to be respected however I proceed. I relish the prospect of tiptoeing, prancing, creeping even toddling through a bluebell wood. Hopping, plodding, jogging, trudging, never: too disrespectful to mother Earth.

DO NOT MOSEY is one of my images whose location I cannot recall. Mostly I can still 'see' myself taking the picture, but some are lost to decaying brain cells and poor record keeping, both of which may raise doubts in your head about my other attributions. Have no fear, I come clean, I will confess such failures, every time one occurs. You might allow my imagination to come up with a likely heading and explanation. Who but the Brits would come up with a public notice so devoted to the national lexicon then fail to explain just why we are forbidden to walk (and, and). Ask us to forbear from stepping.

The photograph of this sign I leave with you for a smile as you reach final page of my stories.

Step gently, look deeply as you mosey.

CODA

CODA ... an often dramatic but temporary ending to a piece of music ... and to some journeys.

Planning and organizing journeys has been a special joy to me all my adult life. Most work out as planned, with unplanned discoveries along the way. I have been humbled when a journey ends in unexpected ways. I neared completion of this book during the summer of 2013. It is now June 2014!

Norfolk birthdays: To celebrate a bundle of family birthdays in March-April 2013, I rented a crenellated 1576 castle in north Norfolk on the eastern coast of England. Ten of us including my Kathy from the US, gathered for professional-quality dinners prepared by our younger ones to meet requests from the birthday folk including for my 80th. We sang old songs. We downed wines from Alsace to Bordeaux to Canada and New Zealand. We scoffed local cockles and oysters, smoked whitefish, roast beef with potatoes and (of course) Yorkshire pud. We damaged a heavy fruit cake beloved of the Brits and a cube of a special cake iced with American and British flags. Sharp, smelly, hard and soft cheeses too, and English fruit. What a birthday bash. We luxuriated in front of roaring fires and slept in four-poster beds as old as the castle. And it snowed enough to prevent my oldest friends coming in from Yorkshire and half my family driving in from Essex. Yet we made a good time of the weekend.

Amsterdam Art: To add another 'coda' to my 80th birthday year, I conceived of some colder journeys as warm weather Kathy could not come. I first booked myself on Eurostar from London St Pancras to Amsterdam. I found an eco-friendly hotel, the Conscious, 100 yards from the famous old Concertgebau where I wanted music. The first night I walked into a man emerging from the box office holding what seemed like a ticket he couldn't use. It was, so I bought my place on the balcony which was perfect for sound and sight. The Orchestra of the Eighteenth Century was performing Mozart's 'Cosi fan Tutti' in costume, without scenery. Witty and wonderfully played and acted. Perfect!

My second evening I walked with my stick and bent back to the guard at the front of the long line at the Rijksmuseum who allowed me to go straight inside. I spent a long time in the refurbished classical galleries, full of Vermeers I have loved all my life. The final painting, another primary purpose of my visit, hung suspended facing me as I approached, all 15 by 17 feet of it: 'The Night Watch' by Holland's famous son Rembrandt. A crowd of citizens looking in all directions quite dramatically different from the orderly rows of other city militia portraits on adjacent walls. The mayor captain leading at the center seemed weirdly to have little pig-eyes staring at me, and his mouth a small O.

The last night I walked another 100 yards and miraculously found a well-appointed brasserie, the Bark. A sea-food meal was my third ambition in Amsterdam: here was exactly what I wanted. In addition to my dinner, I became friends with the next table's couple and then their friends: a five-some party. Moira was Welsh-Dutch, with her companion doing strategic consulting similar to my former profession. From Normandy oysters to Cointreau we celebrated new friendships to be pursued. This is why I journey.

England Round: Back at daughter Pippa's welcoming comfortable home, I made several trips by train. To Bristol for two days with Michael, high by Dundry's hill-top church tower. He and Joyce walked me to Stanton Drew again, one of the largest and oldest stone circles in Britain, one large and two small circles in the

one cow-filled field. Unlike Stonehenge, you can touch and examine every stone: take your time, rain and shine. After our pub lunch we peered at the stones in the pub's garden, now thought to be part of a still older burial barrow. Next day a train detour under the Severn River and along it to Goucester then to Leeds and the local train to Shipley past Dad's old school and our first house at Apperley Bridge by the River Aire. Two nights with Ann and her retired Navy man Tim, up from the south coast for a change in life. I tottered slowly onto the rough grass of Baildon Moor where as a child I played with my two Grandpas: the breezes continue to blow there! And a cuppa tea with Kathleen my oldest friend Geoffrey's widow from Burley in Wharfedale: whiffs of more Yorkshire Dales fresh airs. This is why I journey.

Pippa next drove me to a county I know least, Hampshire, to visit Jane Austen's home in Chawton. Her Decorative Antiques Fair partner is making a replica room of the period with her own antiques for the Fair in January. Pippa and I spent a night in an old pub at the head of wide Candover Valley in the chalk downs. We also had a special visit inside the Austen family house library in its own park setting. Days later I was in trains again, north for a pub lunch with American friends settled in Leicester (leading the University program in Museum ethics). The Cross Country train (out of Bristol) picked me up and dropped me in Cambridge (it continues to Stansted Airport). At 4 pm I walked into my old Emmanuel College for tea with the now retired Master, Richard Wilson and the Development Director Sarah Bendall who both visit America to continue friendships. An hour later I caught the bus outside college to the station for 60 minutes of train back to Pippa in Hatfield. In London a few days later, I met cousin David on the steps of the V&A Museum for their exhibit of Chinese paintings. The oldest in black chalk, more washes than drawings, were close to a thousand years old. They know their medium well in all its many centuries, colours and styles, including storied lay-outs of cityscapes spread across sheet after sheet, a well-spring of illustrated social history. More of why I journey: old-fashioned pilgrimages writ new.

Neolithic Orkney: with Pippa, niece Nicky and husband Ken, in November we four flew beyond Scotland into Orkney, a totally new adventure to sate my curiosity about ancient megaliths. These islands, starting ten miles north of Scotland hold much history including my focus: the biggest crowd of Neolithic stones in Europe and still digging at Ness of Brodgar ceremonial ruins from 5000 years ago. We are seeing artifacts of life, pots and utensils we never expected to find. Brushing our backs against stonework of great skill shaped and cut more like those in the Egyptian pyramids, we walked bent double into the Maes Howe grassy hill rising from its large henge. We marveled at the Stones of Stenness, 6 meters high, sharp grey sandstone slabs alight in the sharp sun and unpolluted air. Our English guide Pat Stone, married to an Orkney farmer (much to Ken's delight), made sure we saw and tasted the best of Orkney's sights and shopping, from Kirkwall's flagstone streets to the Churchill Barriers.

The visitor center at Skara Brae let me use their motorized wheelchair to go the rough track to the edge of the sea to look into the 8 houses still clearly visible from 5000 years ago: sleeping ledges and storage shelving of stone around a square fire pit, and a buried sewage channel using gravity (antique condominiums with buried en-suites!). A vicious hailstorm turned us back. We returned in bright sun a day later. We walked the stone slabs next the sea and the turf walls holding every house. We saw incised patterns on pottery in the mock-up house and museum. Unsuspected artistry among such ancient 'primitive' people in these parts. See www.orkneyjar.com/nessofbrodgar for news from the next surprising remains being excavated.

This whole heart of Orkney is a World Heritage Site with many more sites scattered across the 20 inhabited islands linked by regular ferry boats and some flights. The 80 islands in all hold Scapa Flow, 120 square miles of protected moorings once a Royal Navy base. Rolling grassy fields are full of sheep and cattle. Orcadians are crafting pottery and textiles, making silver jewelry and tasty jams. They are pioneering wave and tidal energy where the Atlantic and North Seas meet. It's Scotland, yet more Norse than Scot (a Norse Earldom for centuries).

We ate substantial breakfasts including black puddings, fresh eggs and bacon, then extensive evening dinners by Harray Loch where a local otter tribe live, an Orcadian sub-species. We drove away in a violent gale and lashing rain. Ken the farmer's strong arms held us straight on the winding roads for the ferry boat back to Scotland's northernmost port and the trains to Inverness. We spent one night by the cold dark hurrying river Ness out of that Loch of the same name.

Here's the rub: on the very last leg to stay with brother Mark, I started an infection turning to sepsis. I landed in a small annexe to the NHS hospital close to daughter Pippa. Kathy flew in. A week later she bundled me into Pippa's car for the ride to Heathrow Airport. Another week later I started a massive bleeding that took two hospitals before an interventional radiologist arriving at 4am knew what to do. He saved my life. Pippa flew in to help for precious time just ahead of Christmas. I started rehab therapy before the New Year and am now home again, wobbly but regaining strength every week.

My final indignity is to have 'swallowing problems' so I can only 'feed' on what I name 'gloop', liquid in cans, five a day. It has no appeal apart from the fact it's putting the right nutrients and calories into me. It sits heavy in me for an hour. 'Don't go swimming after eating' we tell kids! So I rest, read or write and look around me.

We see a swallowing specialist at Johns Hopkins in February. I should never have joked earlier about sitting too long as to lose my legs: I did. But we also achieved my goals for these journeys including spending close rewarding times with many good people especially my English daughter Pippa and my American nurse-in-training daughter Kristy. And Pippa and my wife Kathy bonded more and more.

The good news is that visitors lifted my spirits in conversation. Cards arrived that made me laugh. Christmas, New Year's, Get Well, get Up and Go. Email and phone calls kept me in touch with my worlds, both UK and US. My church includes me remotely and prayerfully, even holding a small service in a hospital room. Now I'm home for 2014 these continue. Friendly spirits fill my air and I am challenged to get out and walk once there is warmth again.

Coda, move over, I'm on my way again.

Share expanded awarenesses.

Discover more moments of beauty.

Nothing is hidden forever.

Live forward.

Pippa is scheming to get us to the Northumbrian coast this summer: long sandy beaches, castles half lost to the sea, ancient Chillingham cattle, Bamburgh in the line of castles, Farne Islands' massed seabirds, Lindisfarne's Holy Island, miles of sands, dunes and pools. I have, too, a map of Ireland open with the coast of Donegal highlighted. A coda is a pause. Let's plan further. Let's look for more beauty. 'Hidden' is in our heads.

<div align="right">

IAN TEMPLE ROBERTS
Alexandria Virginia USA
8 July 2013, 23 August 2013
29 August 2013, 28 March 2014
18 July 2014

</div>

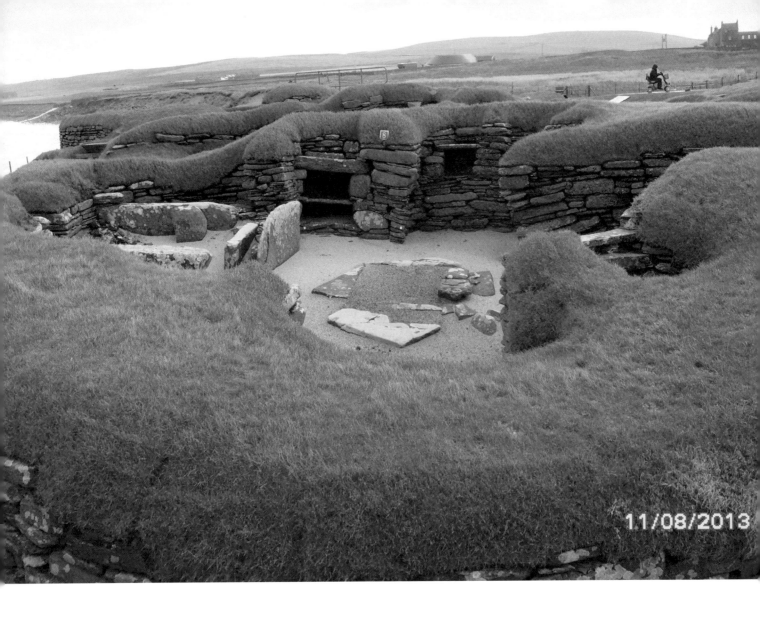

11/08/2013

 5000 year old houses, a total of eight, at Skara Brae Orkney ... we walked along
these turf edges hidden under sands for most of its life until blown into view
by a storm ... now in full view, a moment of beauty ... sometimes we need storms!

Author on Hadrian's Wall

between Scotland and England

Photo Credit: Pippa Roberts.

IAN TEMPLE ROBERTS Admirer of his Dad's 1920-30s English travel albums, Ian started showing his photographs in Alexandria galleries after the double snowstorm of 1996. Back-roads driver and cultural explorer, specialist guide for 60 years (Europe, New Zealand), history teacher. Director of sales (vending) and business development (chemical engineers) in Europe, Asia and North America. Co-leader for multi-cultural workshops in strategic planning, leadership and team training (international organizations). He worked in Ivory Coast, Haiti, and countries colored red on old British maps. He settled in Alexandria Virginia in 1978. Life-long amateur student of people, art, architecture, archaeology, faiths, freethinking Episcopalian, and 'spiritual listener'. Published poet in his book 'Figments and Fragments' and with the writer's group Tuesdays at Two. Once stroke of his Emmanuel College first crew he has a Cambridge history MA. He values his Victorian-Edwardian parents, his environmentalist NY wife, Asian-American young, family-friendships of all ages both sides of the 'Pond'. Books, music, photographs, journeys, wild green views from his chair, walking and talking keep him alert.

CPSIA information can be obtained at www.ICGtesting.com
Printed in the USA
BVIW12n0055070415
394990BV00003B/3